NEW YORK IN COLOR

NEW YORK

IN

COLOR

Nichole Robertson

CHRONICLE BOOKS

SAN FRANCISCO

Library of Congress Cataloging-in-Publication Data available.

ISBN 978-1-4521-5476-3

Manufactured in China

Designed by Kristen Hewitt

10 9 8 7 6 5 4 3 2 1

Chronicle Books LLC
680 Second Street
San Francisco, California 94107
www.chroniclebooks.com

To New Yorkers

INTRODUCTION

When I first fell for New York City, I fell hard and fast. I blame my friends for setting us up. It was their balcony, with its sweeping, unobstructed skyline view, that sealed the deal. They had suggested I get "a little fresh air," knowing well that the twinkling lights and infectious energy would woo me. By the time I came back inside, I had picked out the neighborhood I would call home. That view and rash decision put me on the path to a successful writing career, my wonderful family and great friends. It also put me on a path to roach-infested apartments with laughable rents, and the kind of broke that means sleeping on the floor and making two meals out of a cheap bagel bought at 10:30 a.m.

Those kinds of contradictions define life in most cities, but New York is practically built on them. After a decade of keeping up with its frantic pace, I needed a break. So with the same certainty with which I had moved to New York, I packed up and moved to Paris.

And Paris was the perfect antidote to New York. I quickly came to appreciate the Parisian pace and enjoyed taking the time to get to know my new neighborhood, camera in hand. Over the course of many long, therapeutic strolls, I discovered that shooting the city

one color at a time short-circuited my preconceptions about what was worth photographing. This process led me to shoot a host of beautiful, but mundane subjects—metro signs, empty chairs, fading graffiti—and I realized that not only were the stereotypical Parisian subjects unnecessary to telling the city's story, in many ways they were a hindrance. The results of these serendipitous discoveries are documented in my first book, *Paris in Color*. Later that year, when work brought me back to New York, I returned rejuvenated, and with two essential lessons that made the book you are holding possible: How to tell the story of a place through everyday objects, and how to slow down long enough to see them.

Upon returning, I saw New York with fresh eyes. Meandering through the streets revealed so many beautiful details I had ignored, as I rushed to the subway or sprinted toward whatever appointment for which I was late. And I had a new appreciation for the city's comically chaotic juxtapositions: A sign warning "post no bills" with snarky responses written just underneath, Gothic architecture next to a neon wash-and-fold sign, an elegant mural of a ballerina floating above a rusty chain-link fence. Feeling giddy on the energy (and just a little silly walking so slowly), I began photographing the distinctive

details that now stood out in sharp relief. I wanted to capture the mix of the high and the low, the gritty and the grand—the contrasts that give New York its tense, infectious energy. Some things remain fixtures of the city of course—the yellow cabs, one-way signs and brownstones. Even the fruit stands, which I have seen on virtually every street corner over the past twenty years, still offer bananas at four for a dollar. But the most constant things in New York are the forces of change. Construction sites and scaffolding may switch locations, for example, but they're always there—a defining part of the city.

These are the touchstones that define New York for me—the conversations on bathroom walls, the laundries, the delis, the parking tickets (yes, even the parking tickets!). While shooting this book, I revisited favorite places, retraced the steps of my earliest days in the city, and walked both familiar and unfamiliar streets with what to New Yorkers must have seemed like a maddeningly slow pace. But that's when the magic happens.

No one neighborhood or monument can define the city, and similarly, no single photo in this book defines New York. It's the cumulative effect of colors, textures and everyday objects that reveal a city's true personality. My aim was to capture that personality through New York's often overlooked quirks and charms and to re-create a slow walk on what are typically fast-paced streets. I hope you enjoy the stroll.

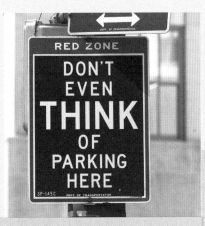
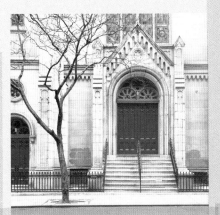
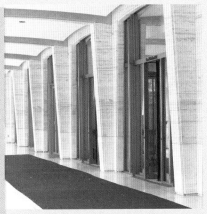
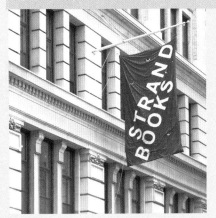
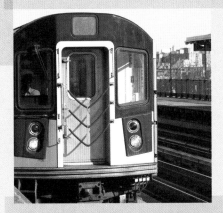
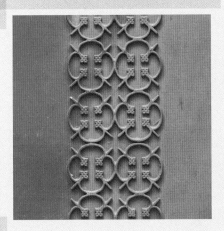
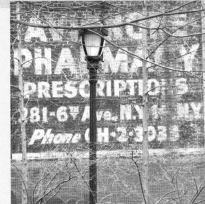
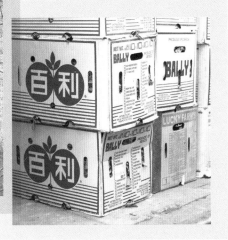

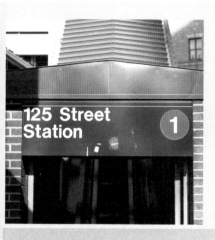

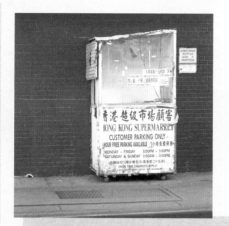

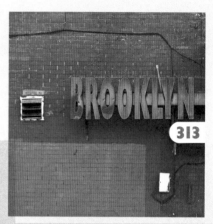

RED

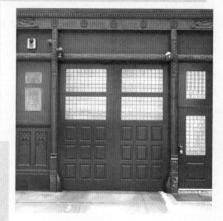

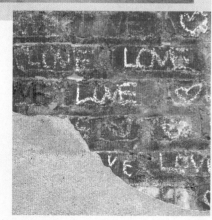

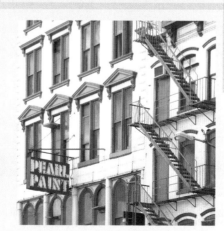

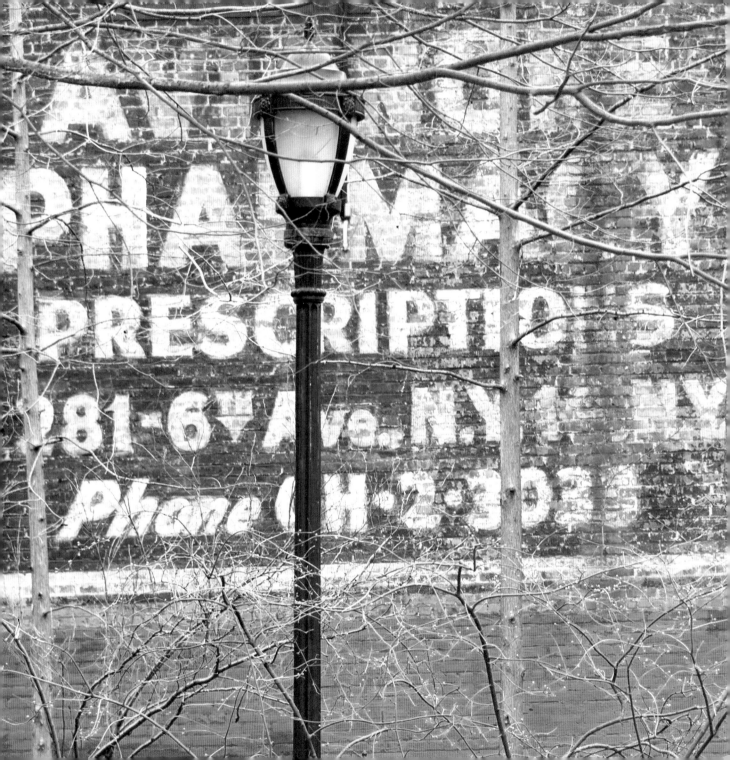

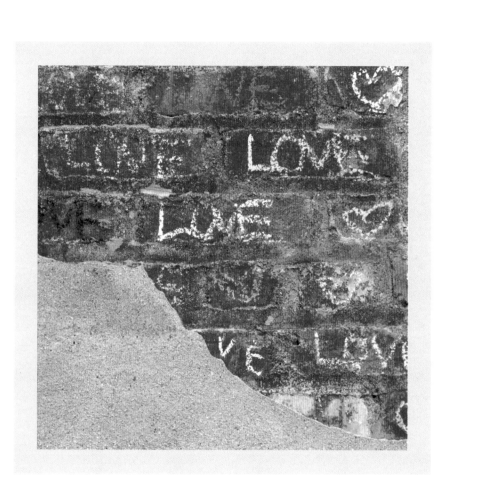

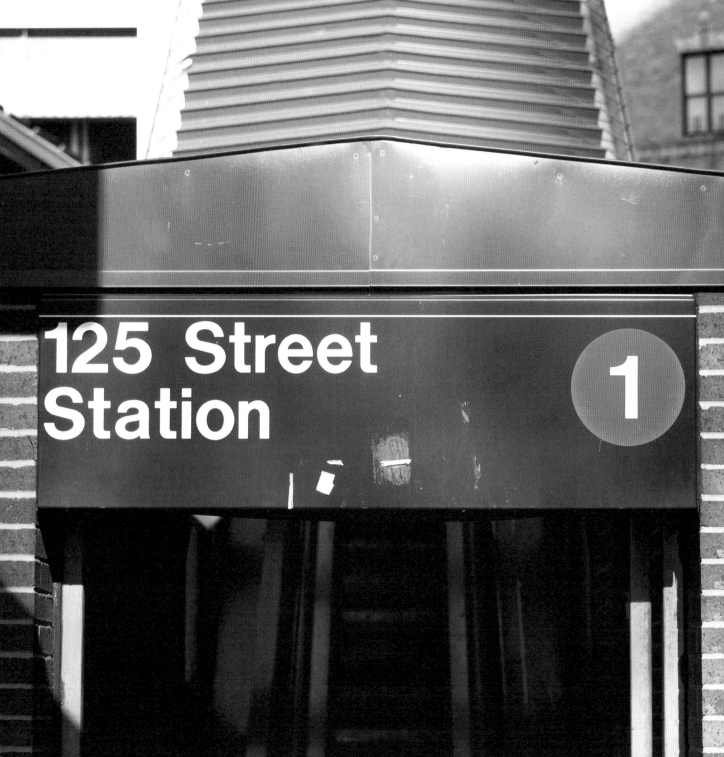

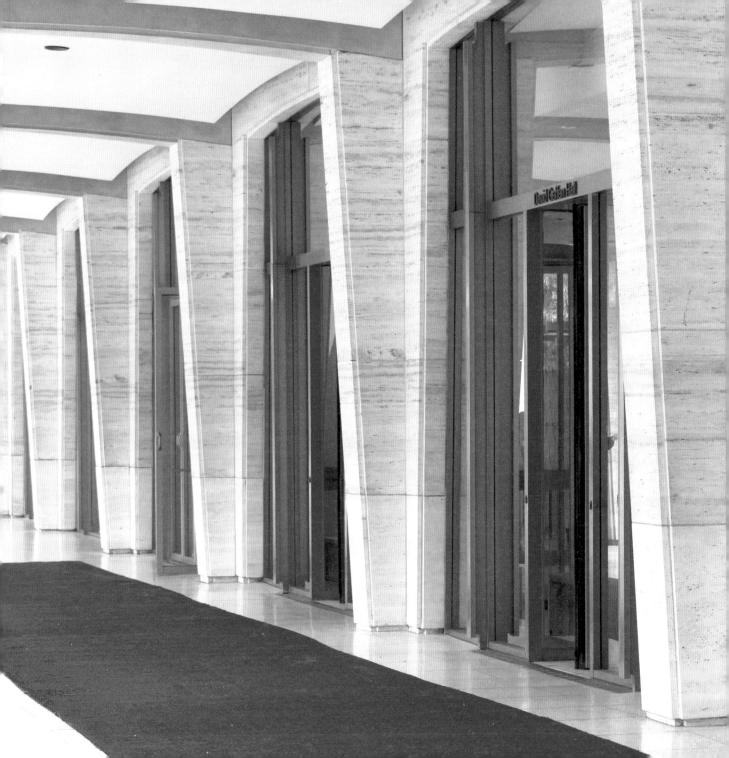

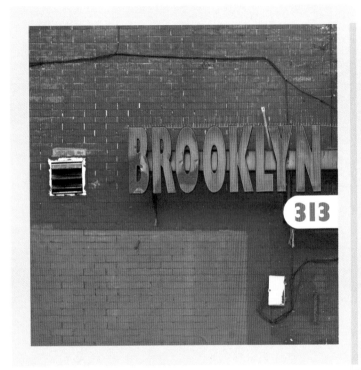

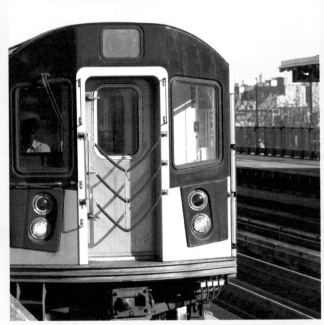

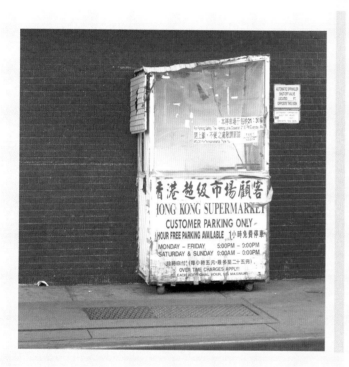

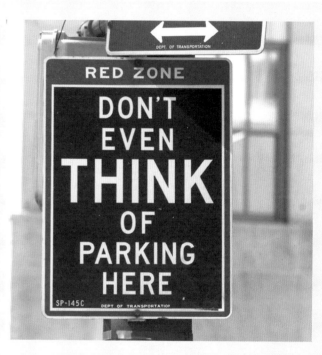

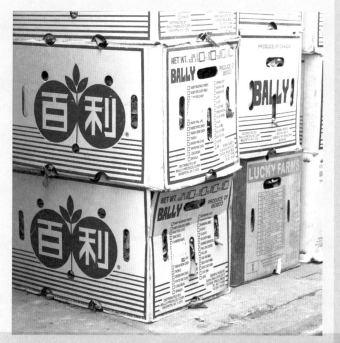

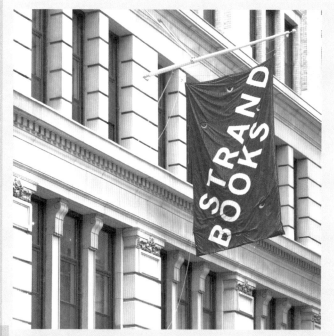

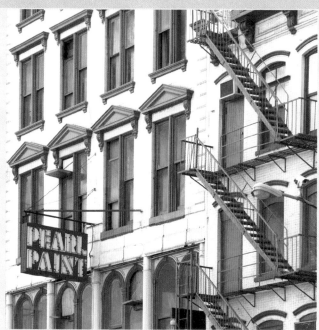

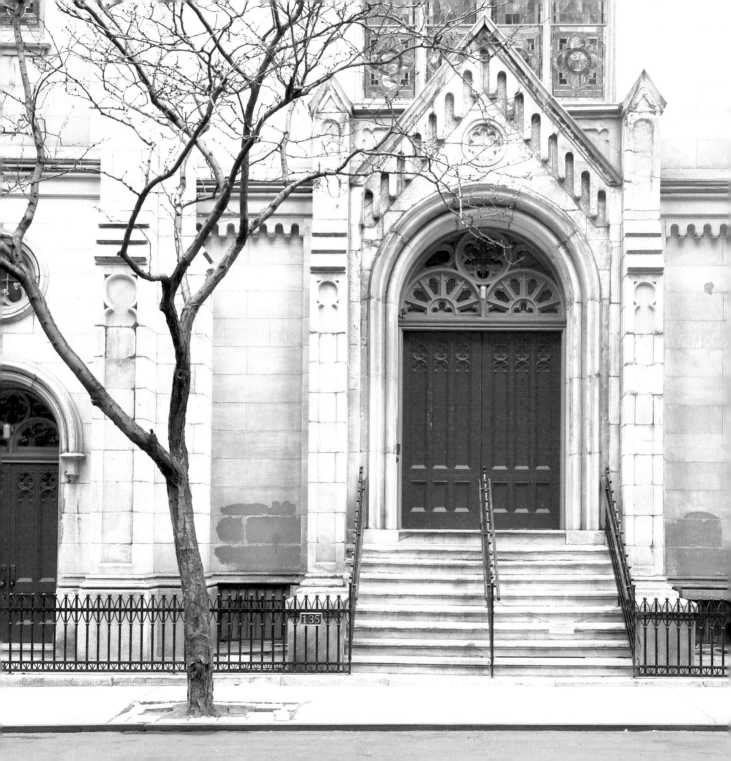

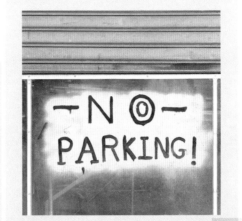

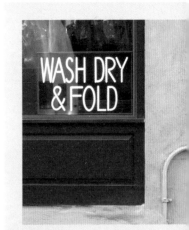

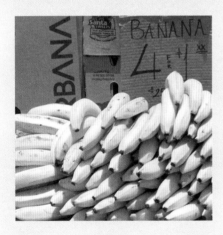

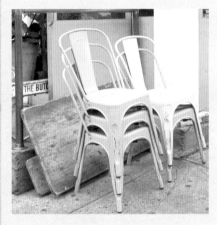

YELLOW

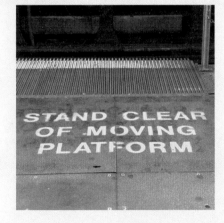

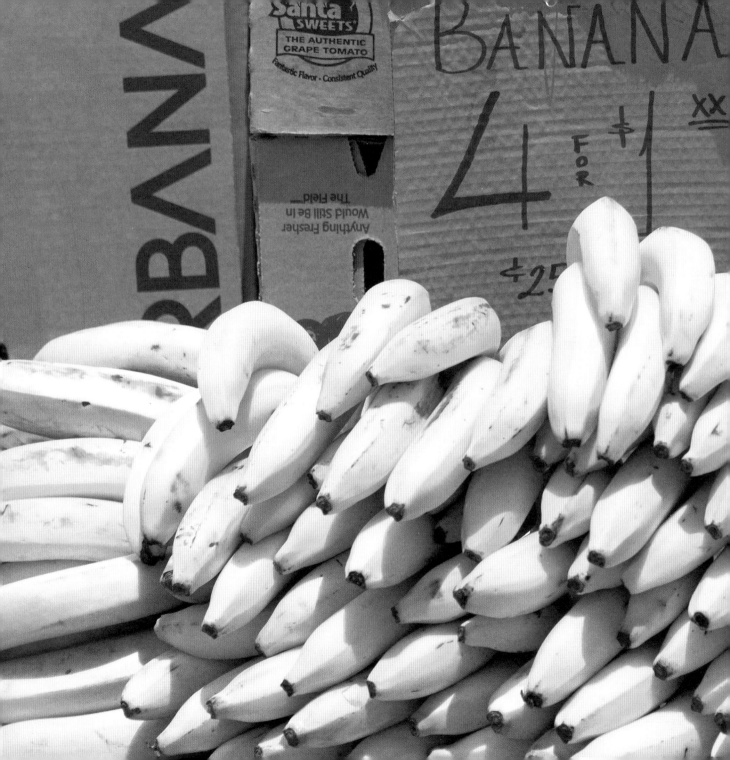

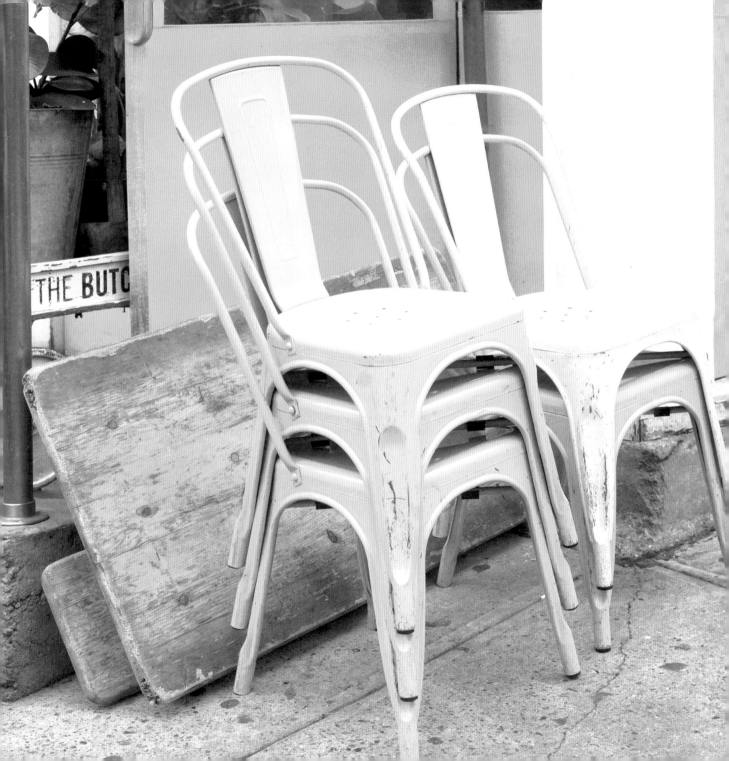

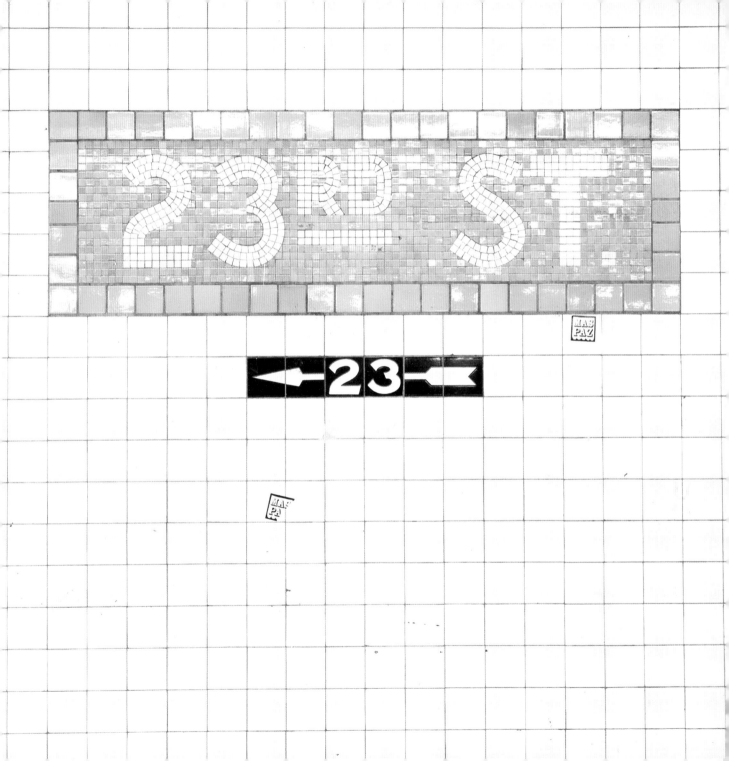

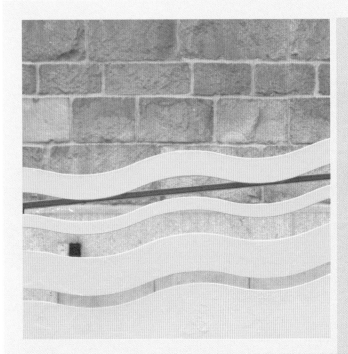

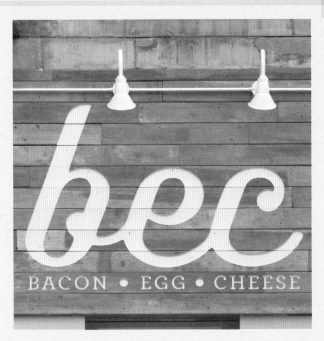

bec

BACON • EGG • CHEESE

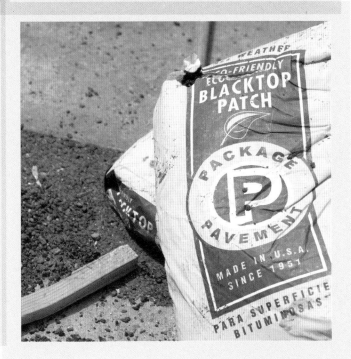

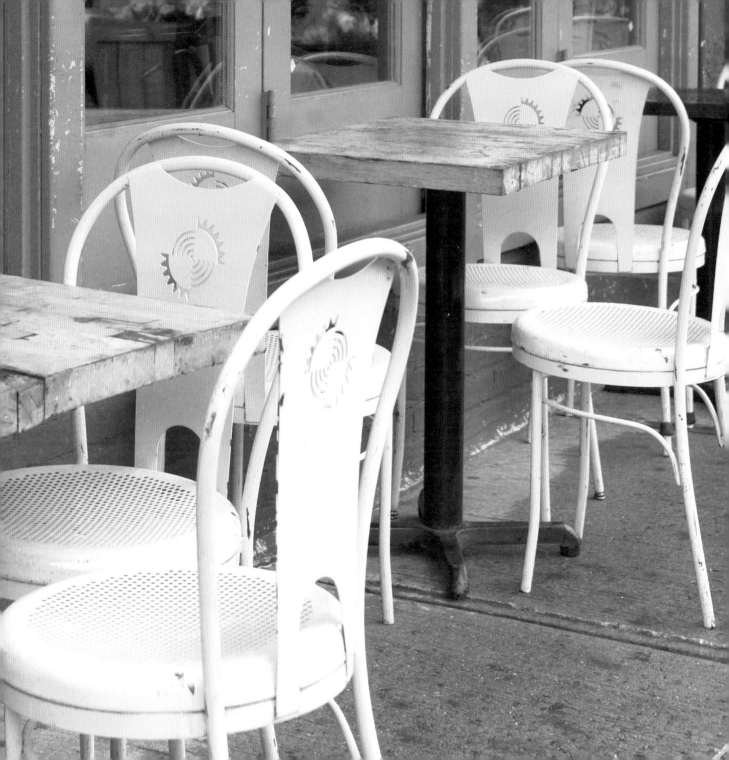

WASH DRY
& FOLD

— N ⊙ —
PARKING!

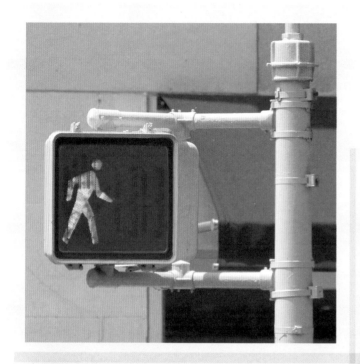

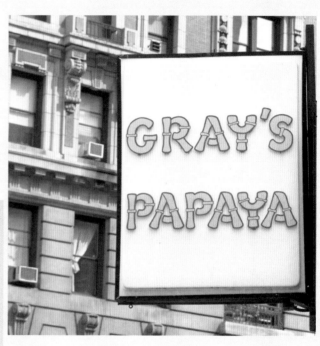

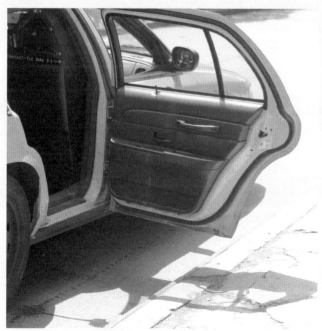

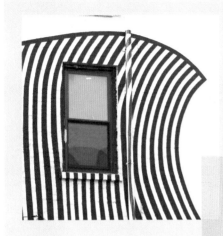

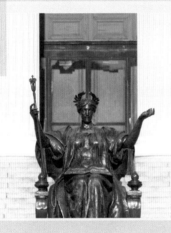

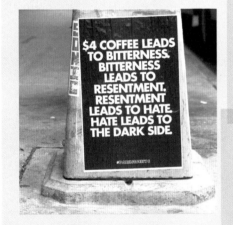

$4 COFFEE LEADS
TO BITTERNESS.
BITTERNESS
LEADS TO
RESENTMENT.
RESENTMENT
LEADS TO HATE.
HATE LEADS TO
THE DARK SIDE.

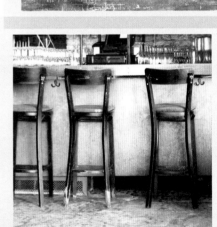

HOGS & HEIFERS
SALOON

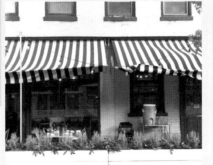

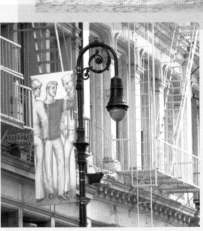

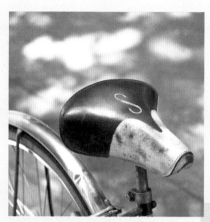

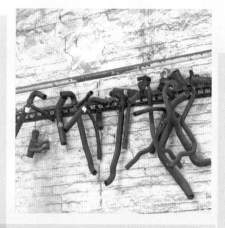

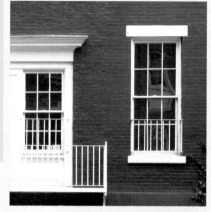

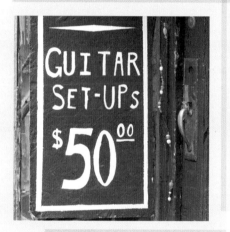

GUITAR
SET-UPs
$50⁰⁰

BLACK

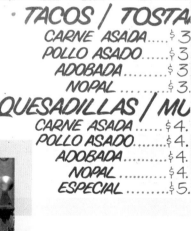

· TACOS / TOSTA
CARNE ASADA......$3
POLLO ASADO......$3
ADOBADA..........$3
NOPAL............$3.
QUESADILLAS / MU
CARNE ASADA......$4.
POLLO ASADO......$4.
ADOBADA..........$4.
NOPAL............$4.
ESPECIAL.........$5.

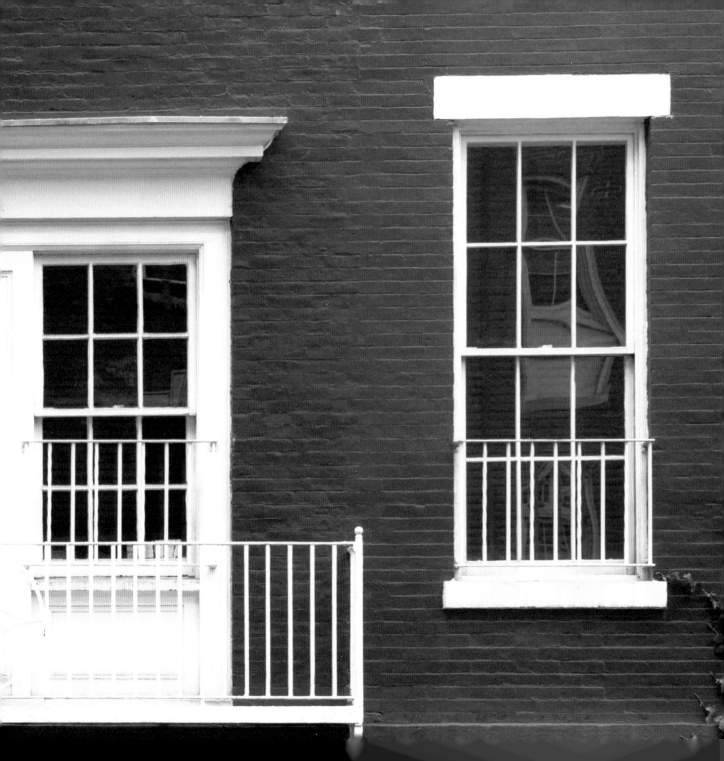

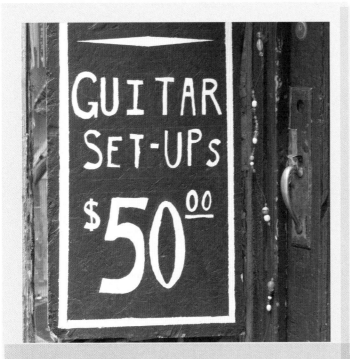

GUITAR
SET-UPs
$50.00

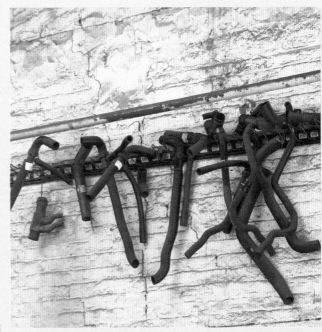

- TACOS / TOSTA
 CARNE ASADA.....$3
 POLLO ASADO......$3
 ADOBADA..........$3
 NOPAL...........$3.

QUESADILLAS / MU
 CARNE ASADA......$4.
 POLLO ASADO......$4.
 ADOBADA..........$4.
 NOPAL...........$4.
 ESPECIAL.........$5.

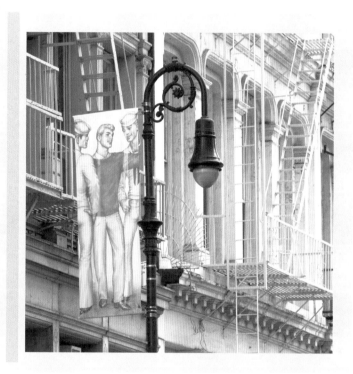

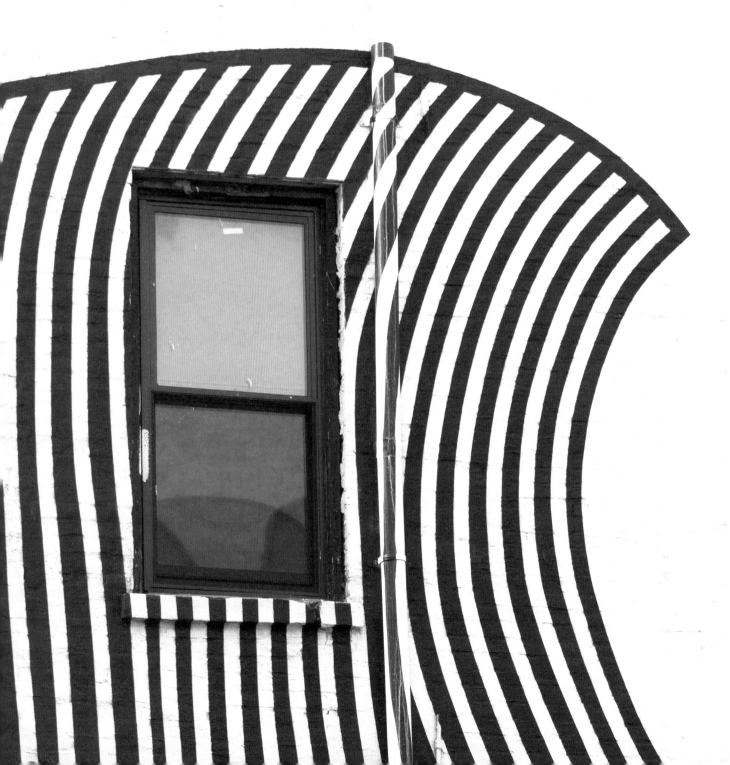

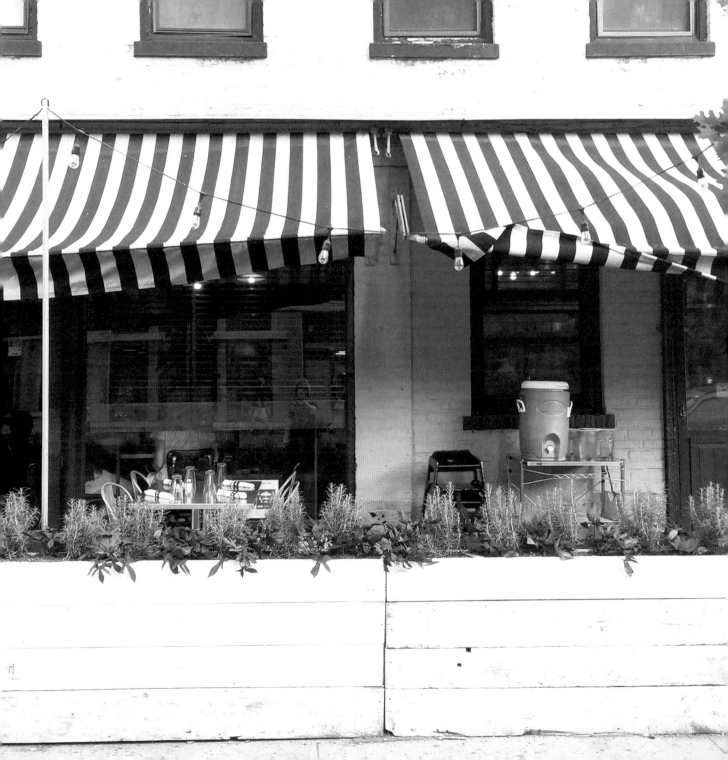

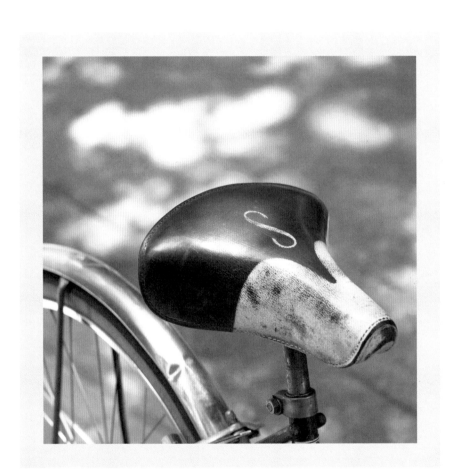

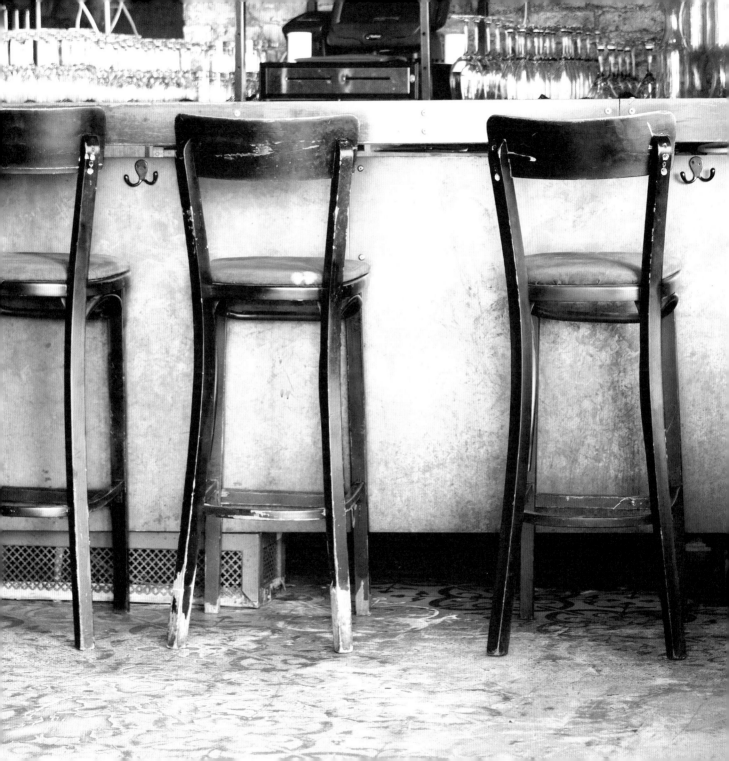

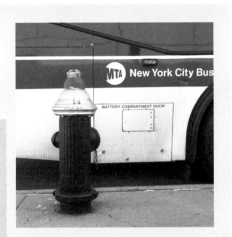

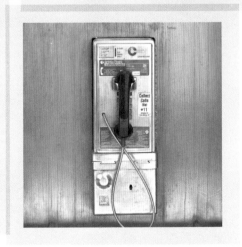

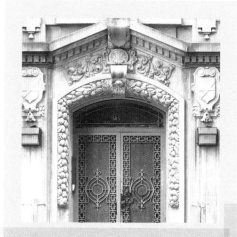

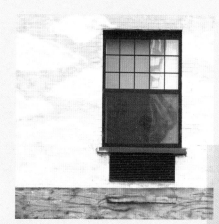

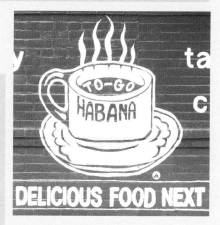

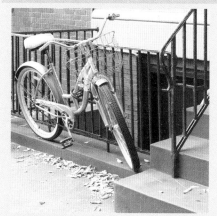

BLUE

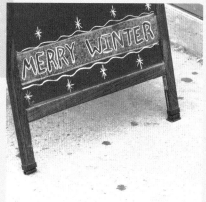

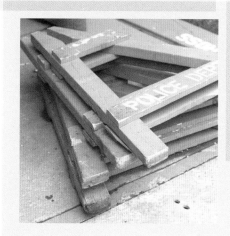

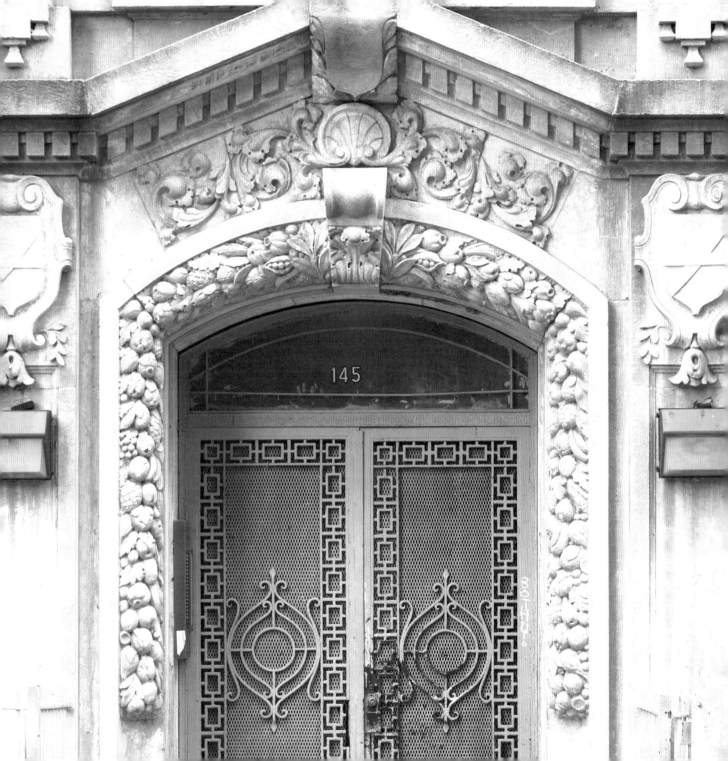

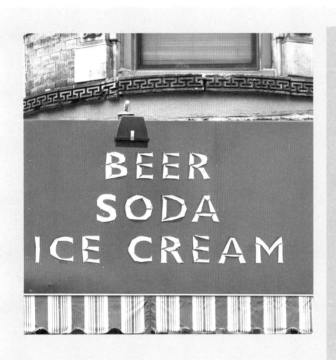

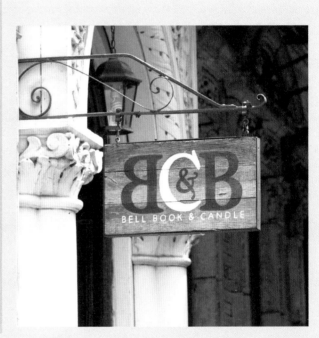

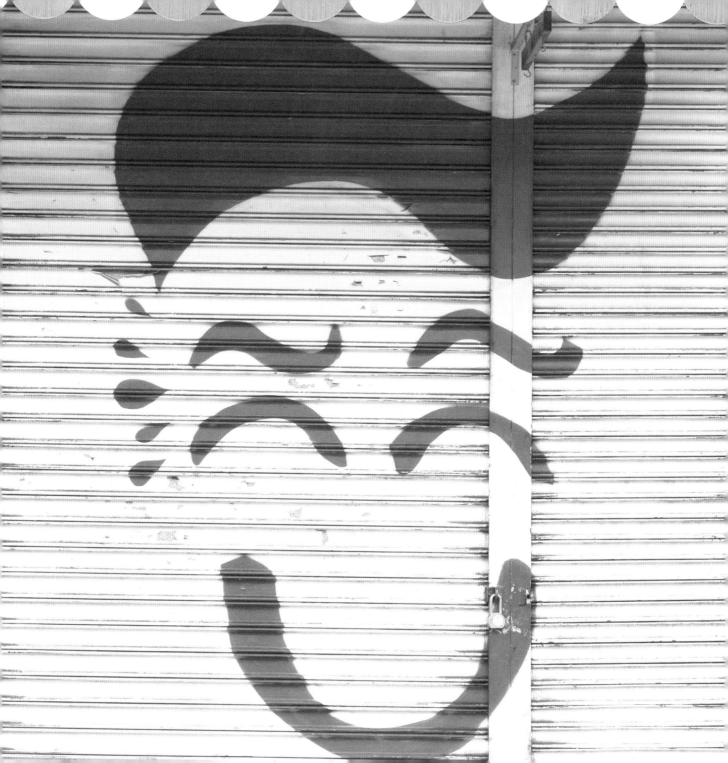

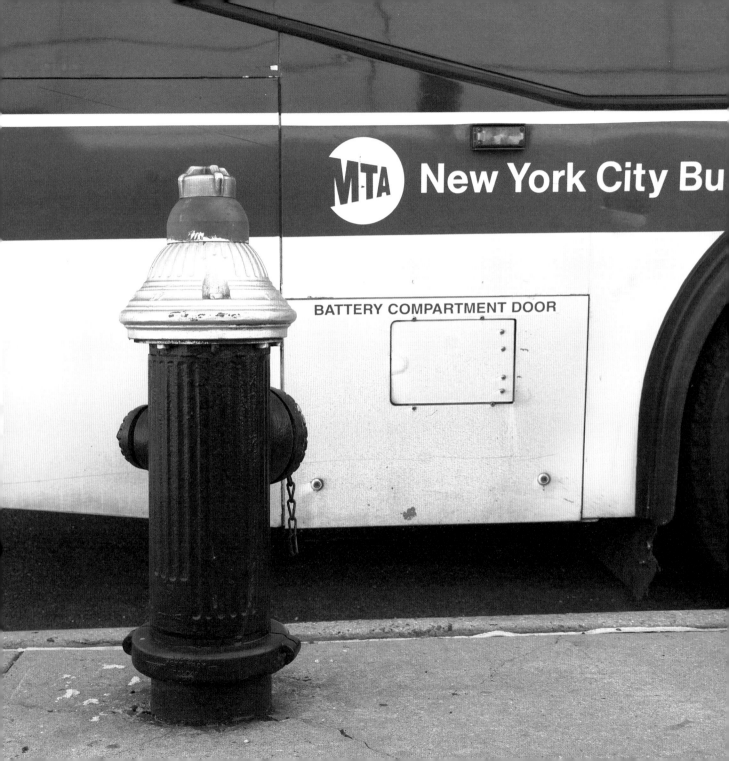

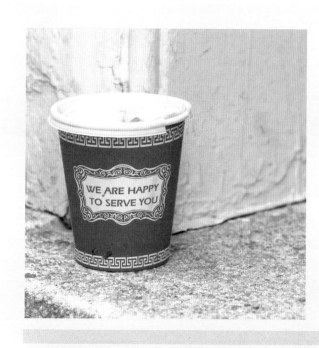

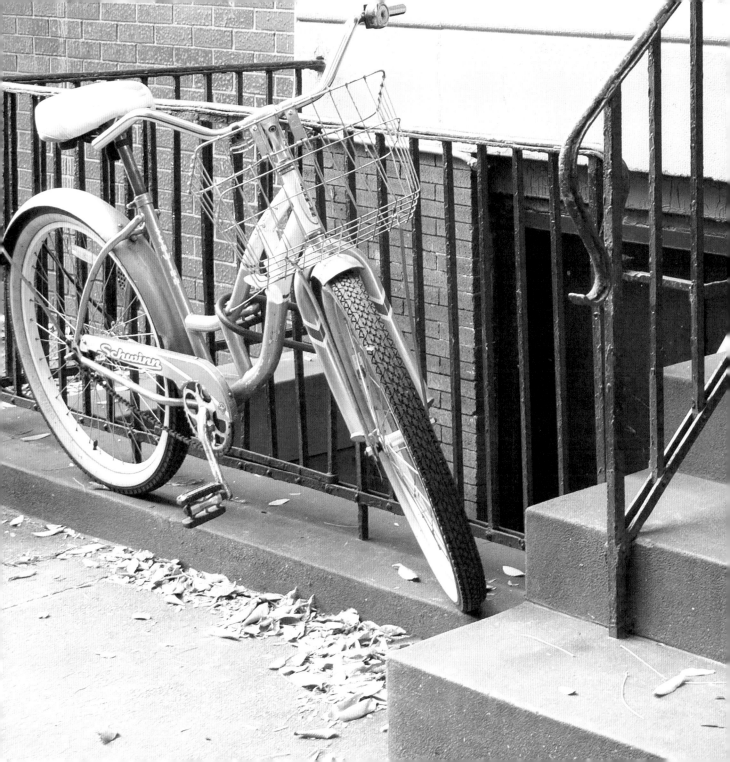

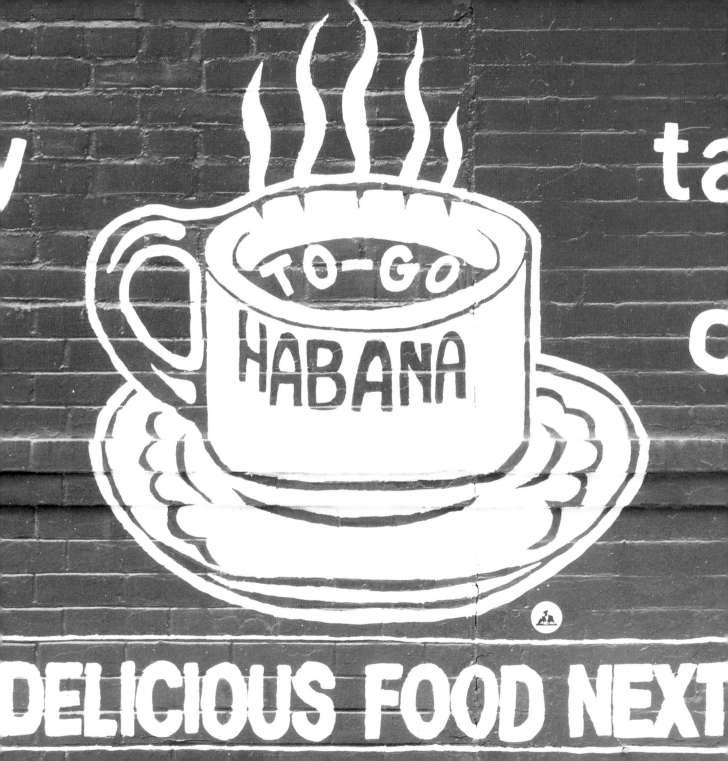

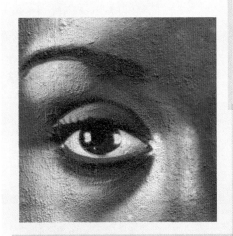
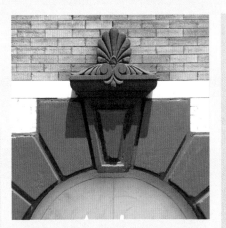
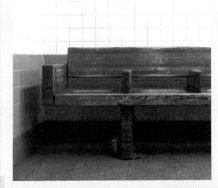
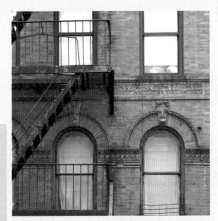
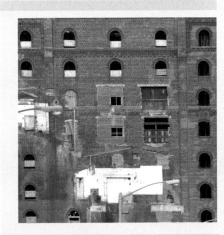
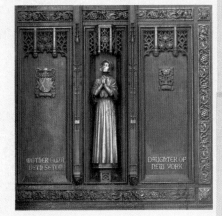
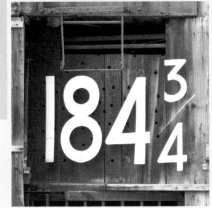
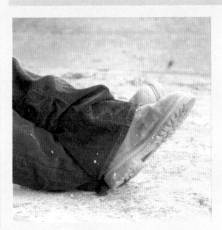

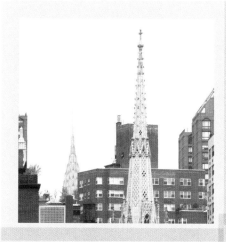
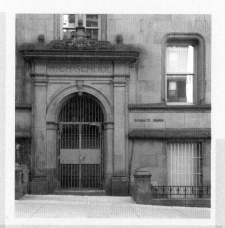
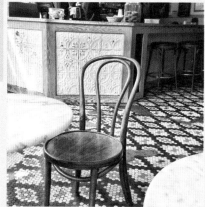
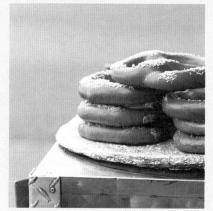

BROWN

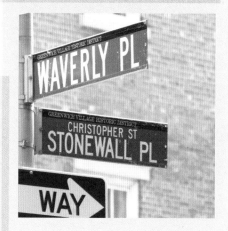
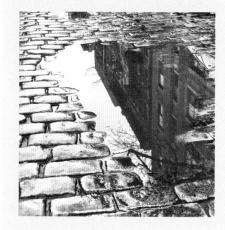
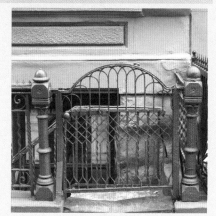

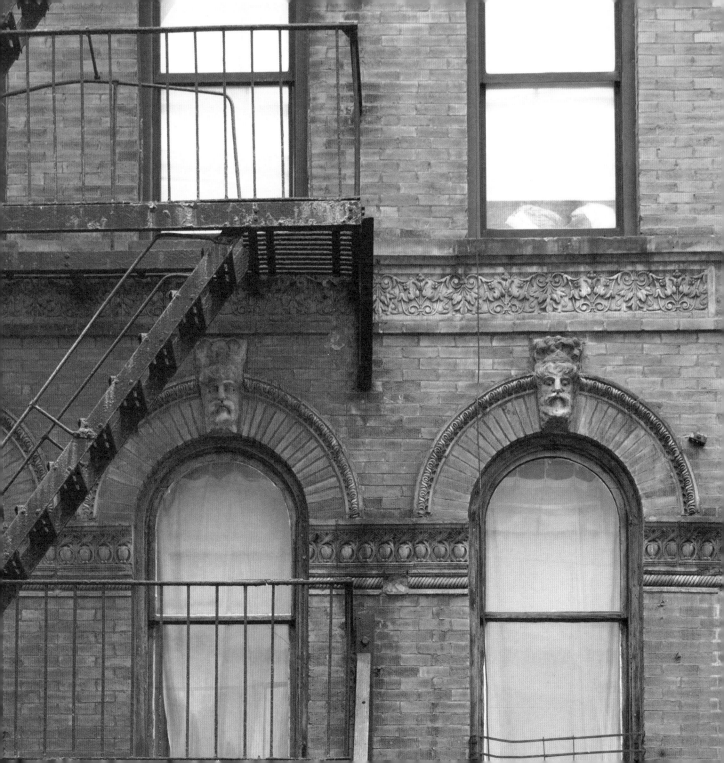

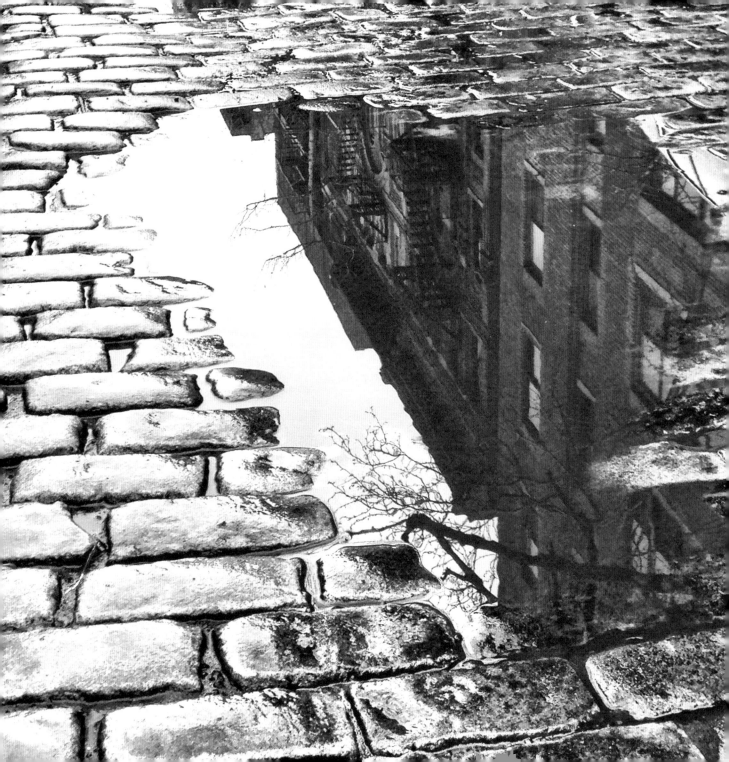

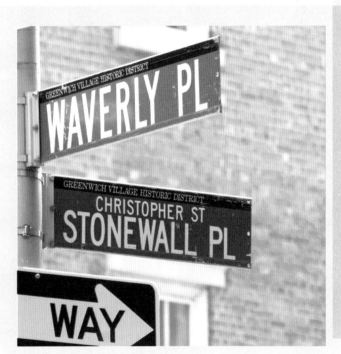

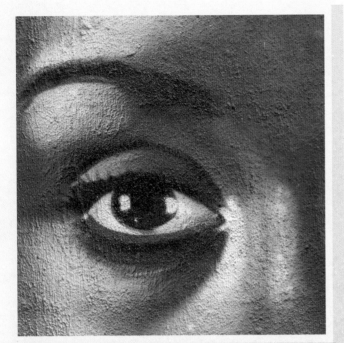

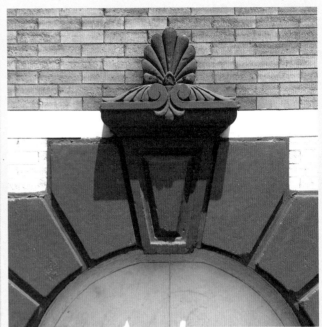

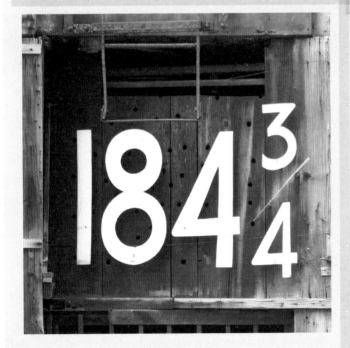

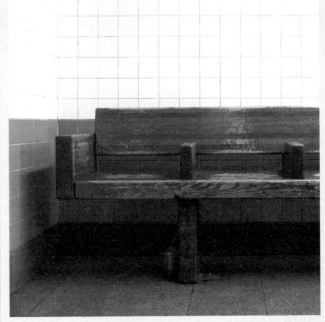

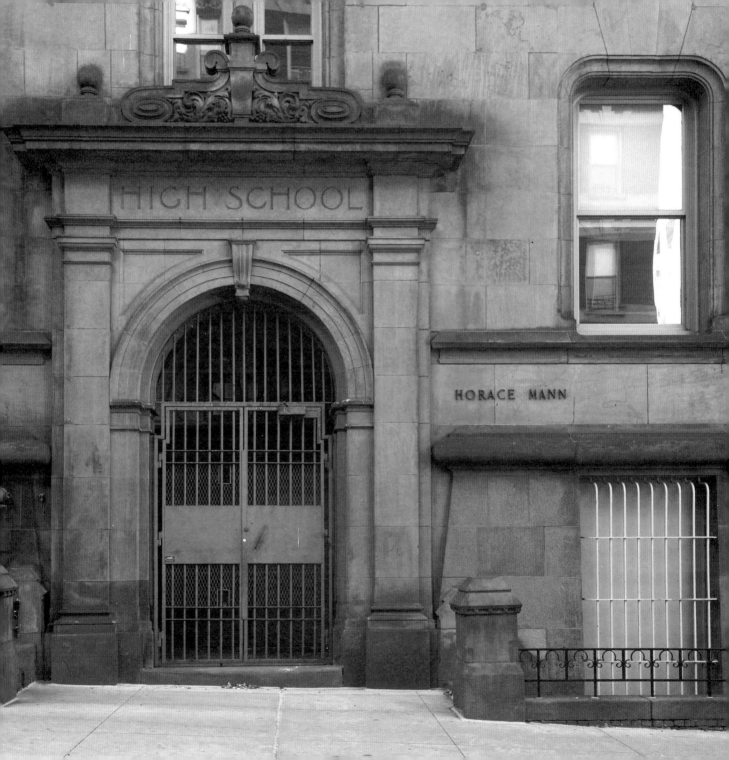

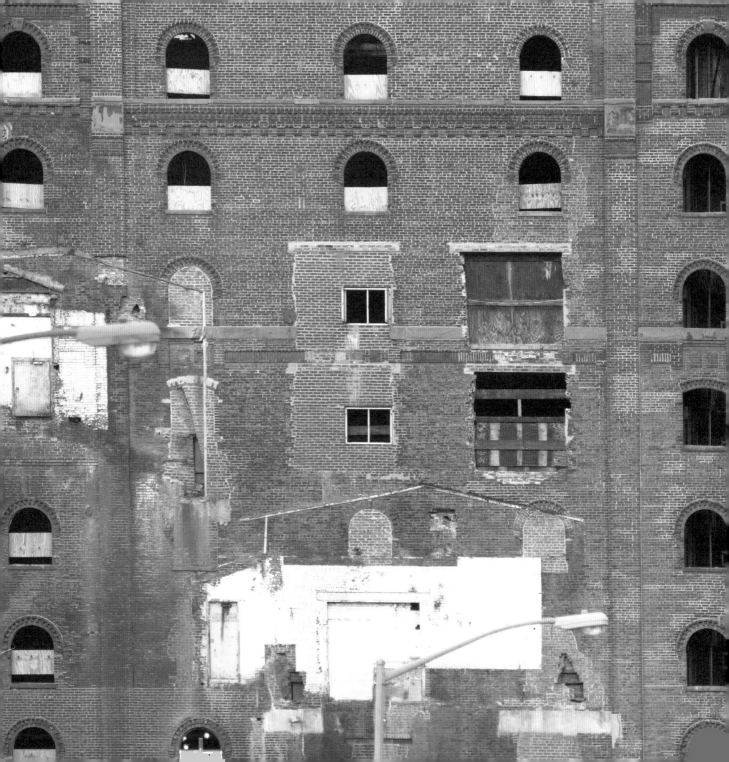

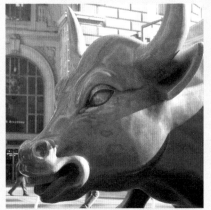

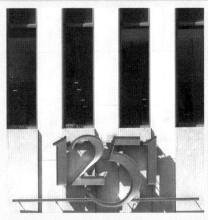

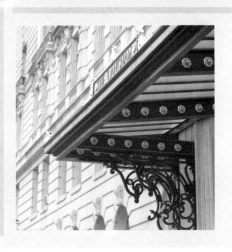

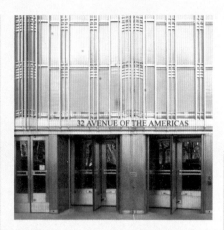

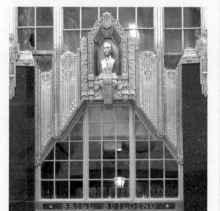

GOLD

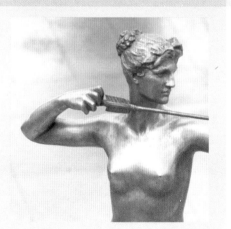

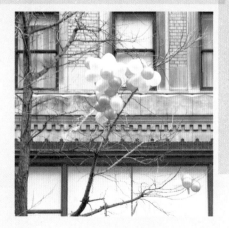

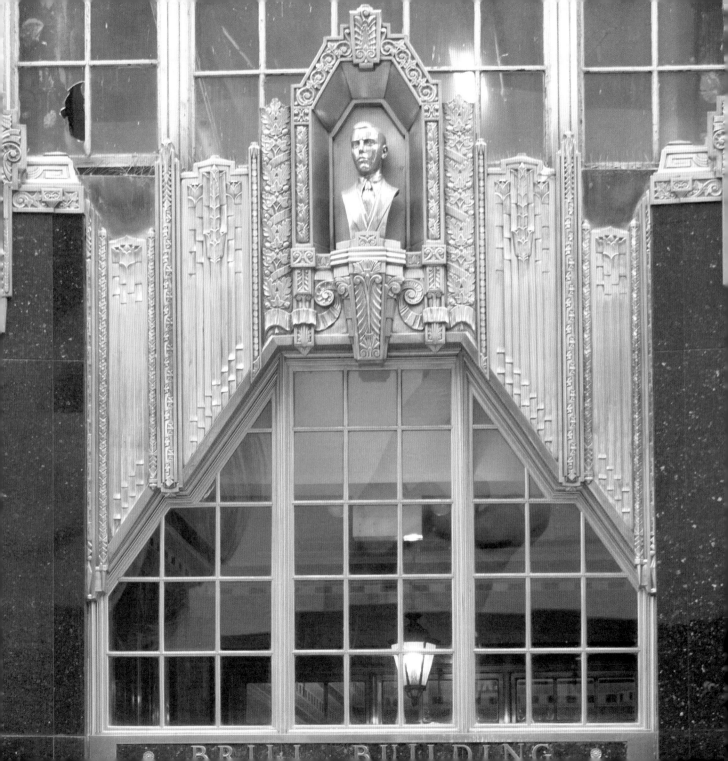

BRILL BUILDING

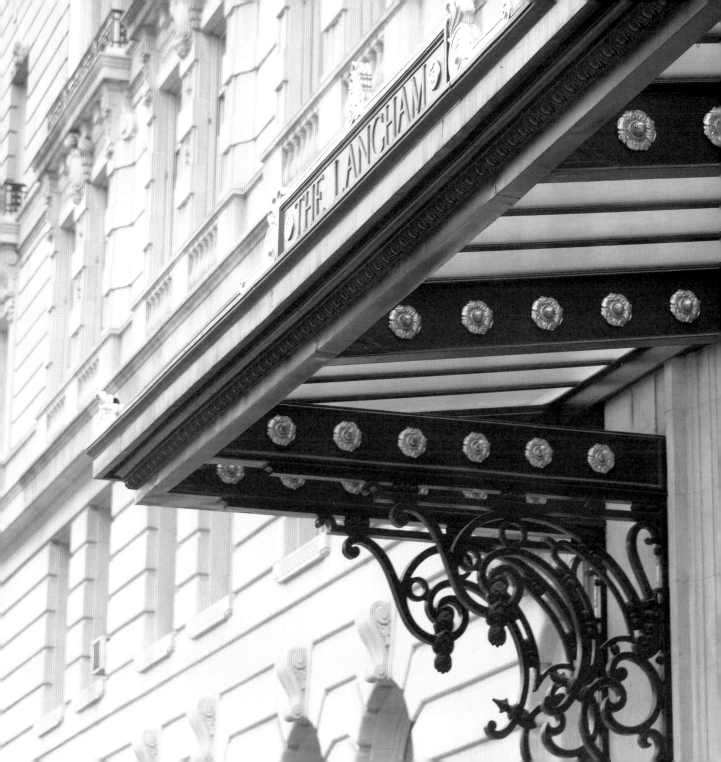

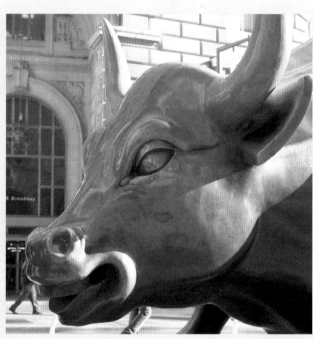

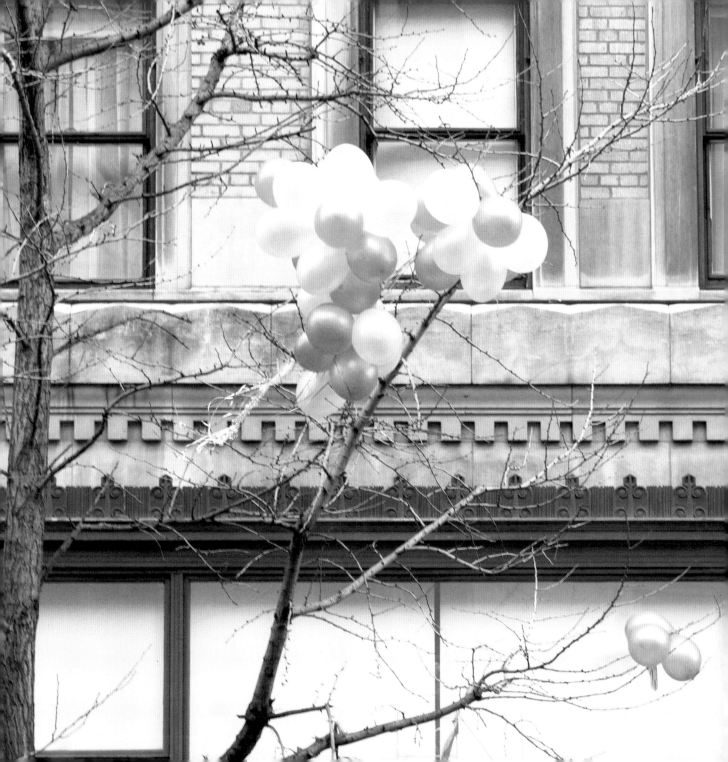

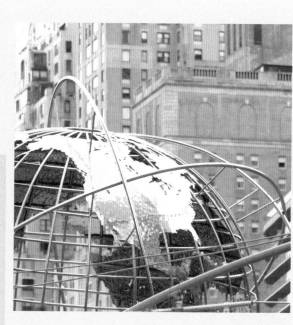

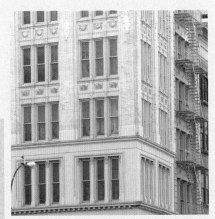
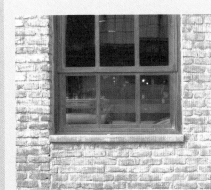
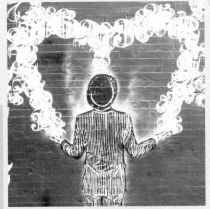

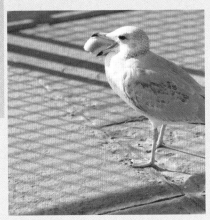
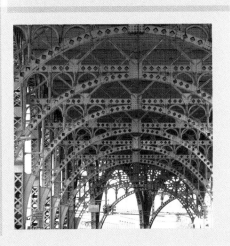

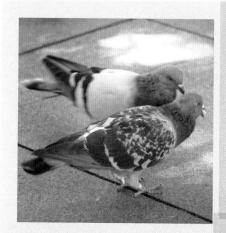

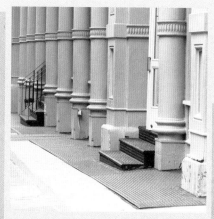

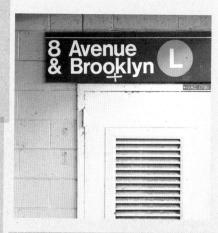

GRAY

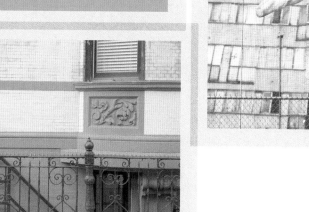

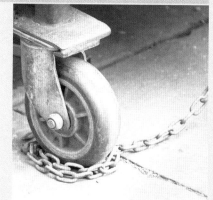

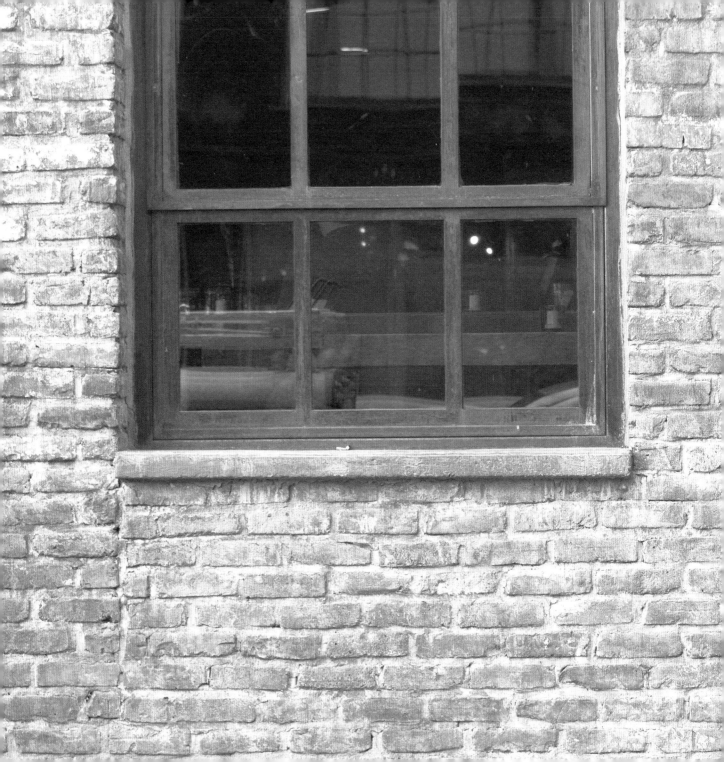

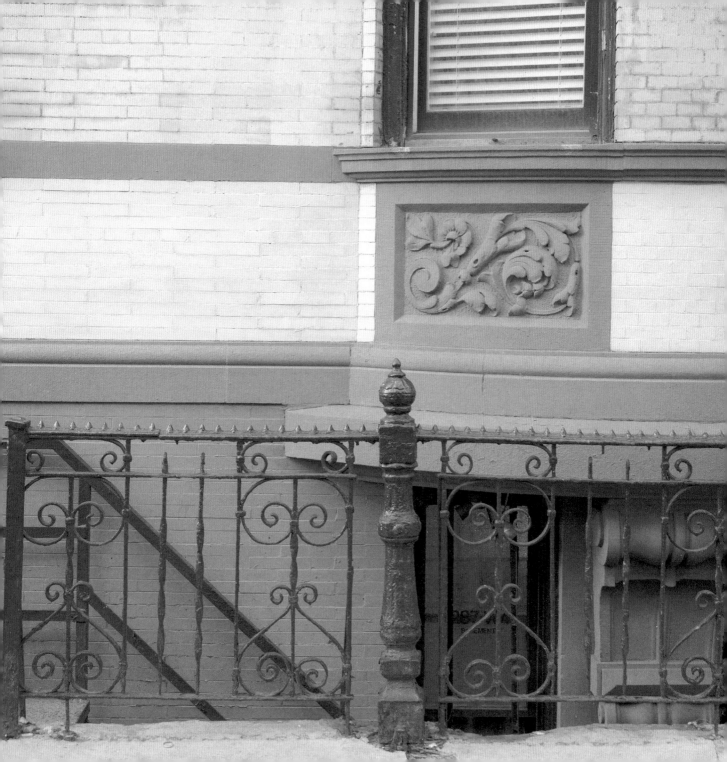

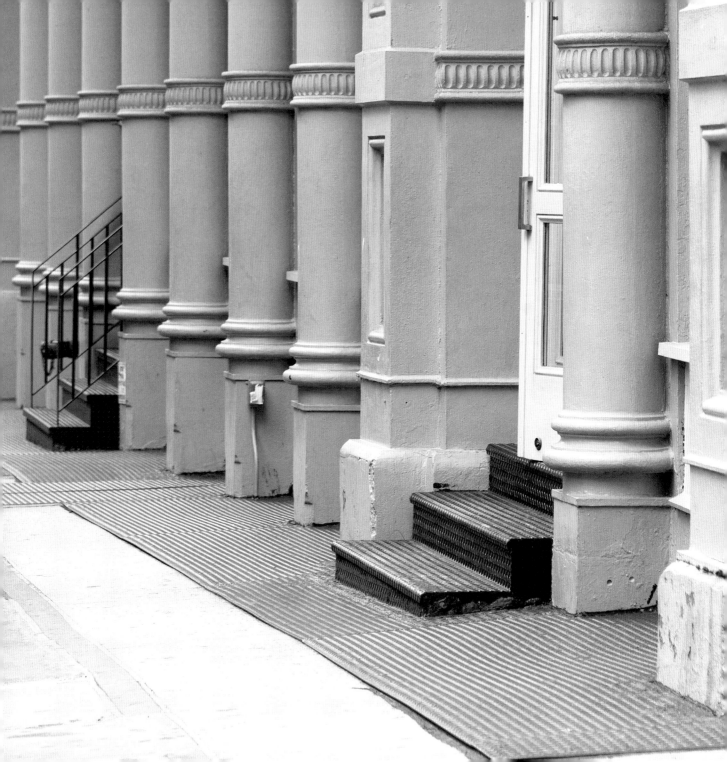

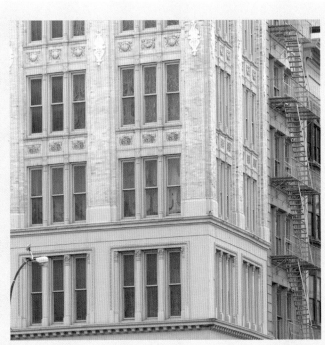

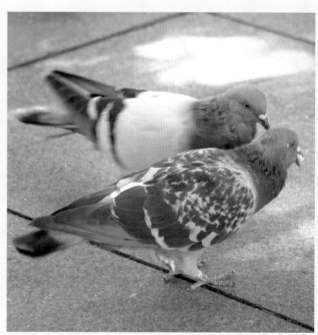

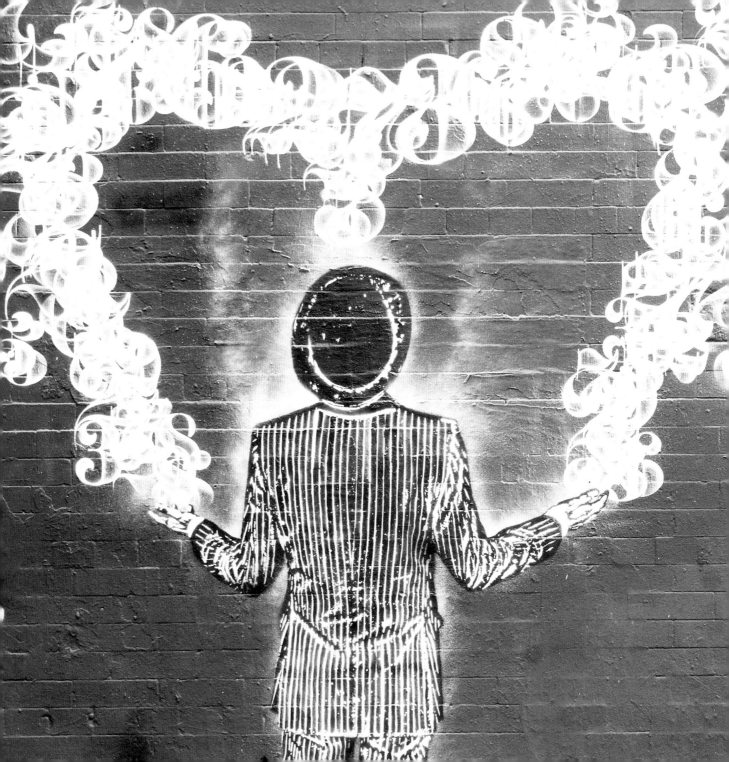

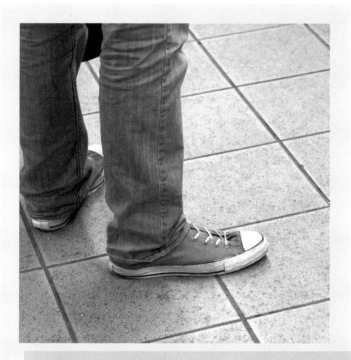

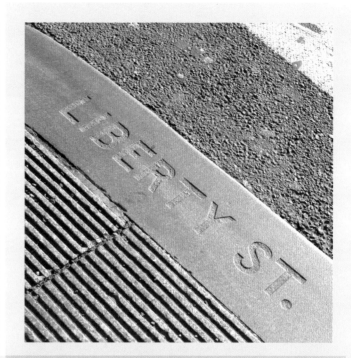

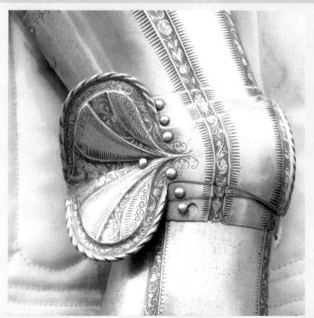

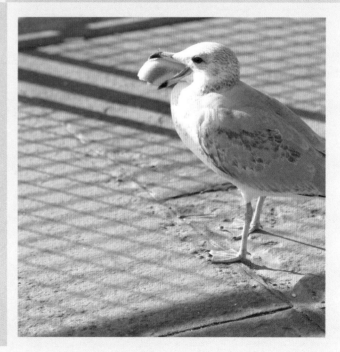

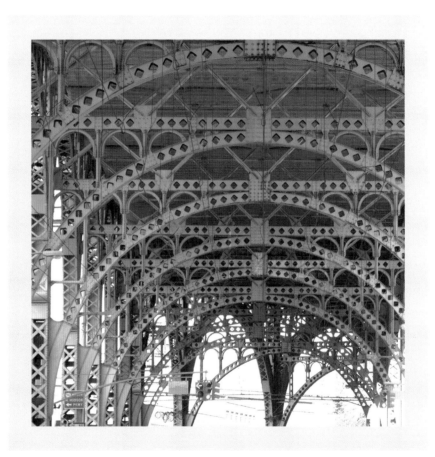

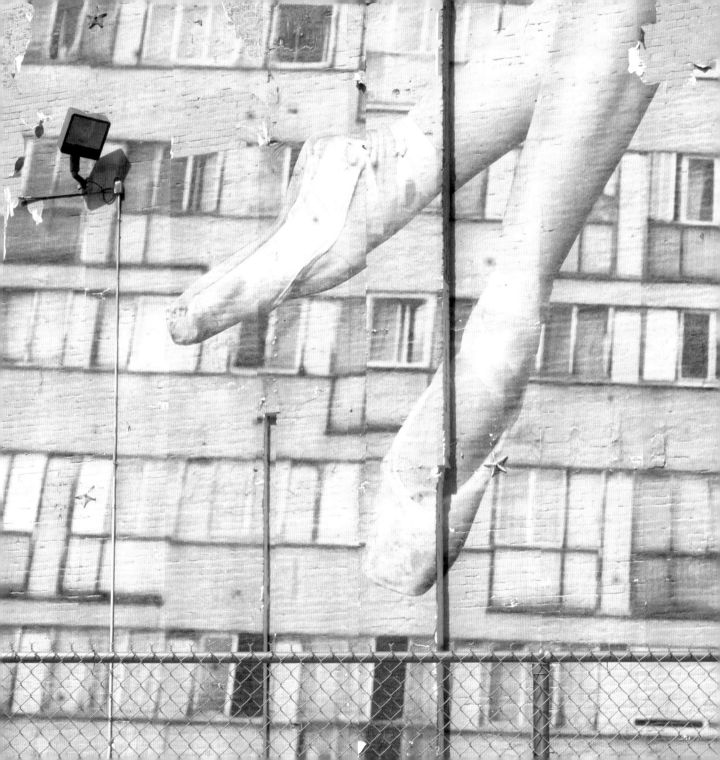

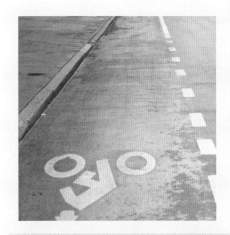
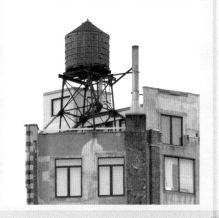
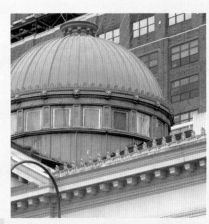
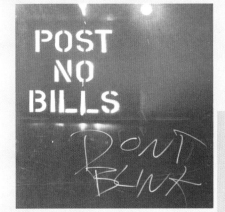

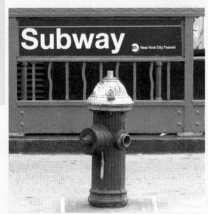

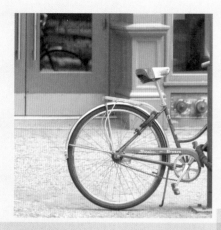

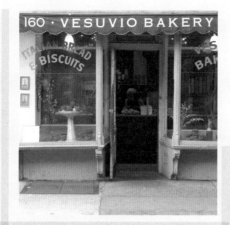

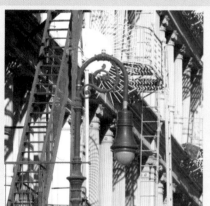

GREEN

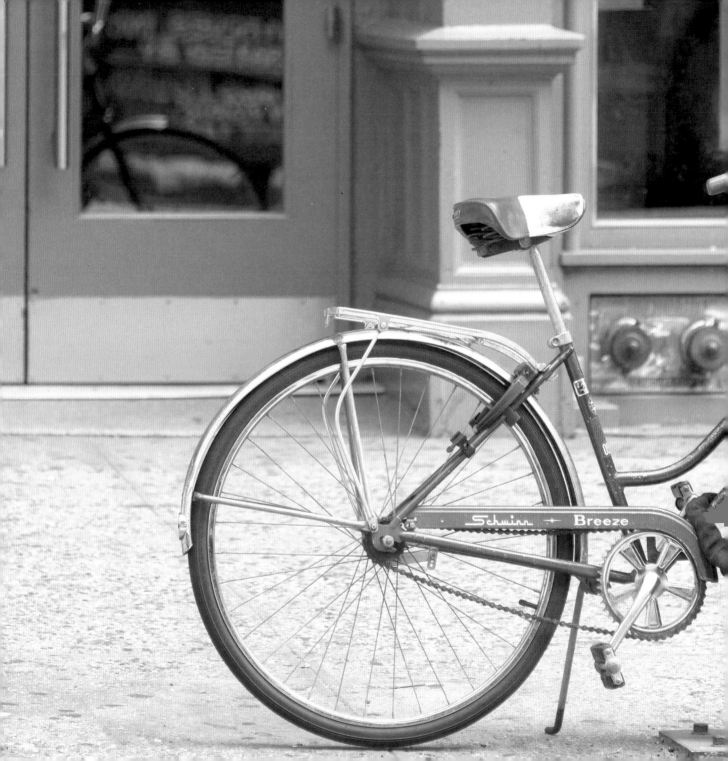

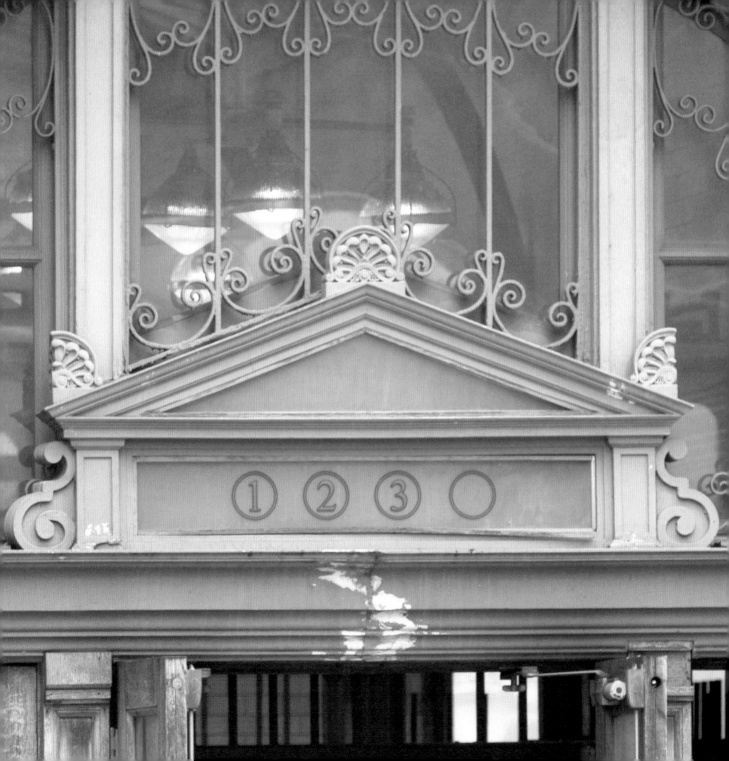

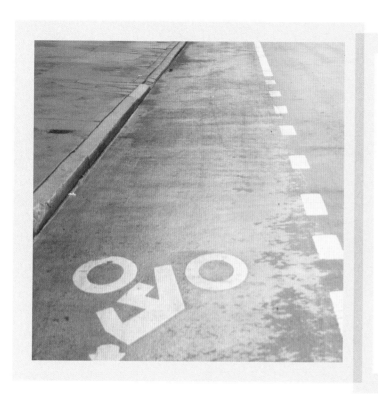
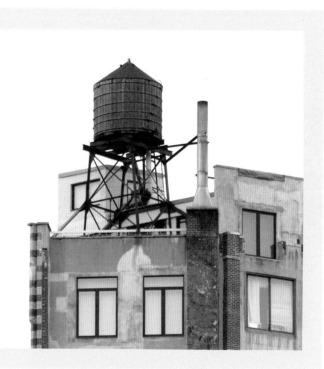

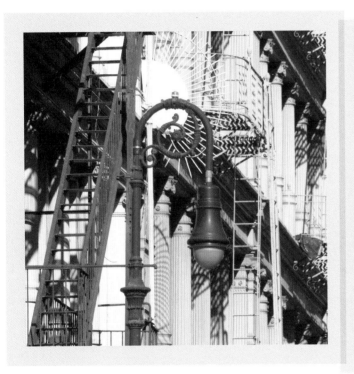
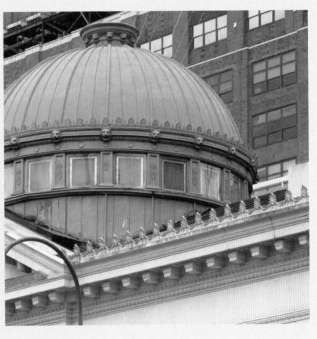

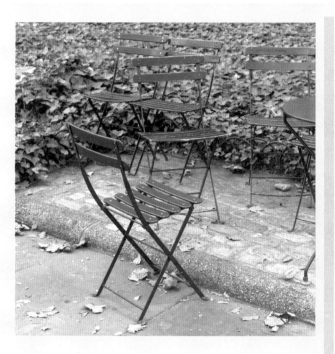
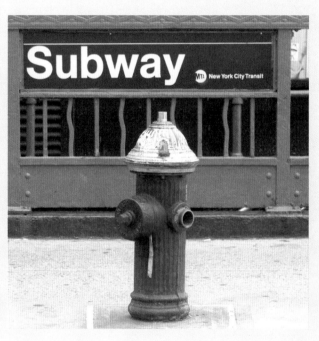

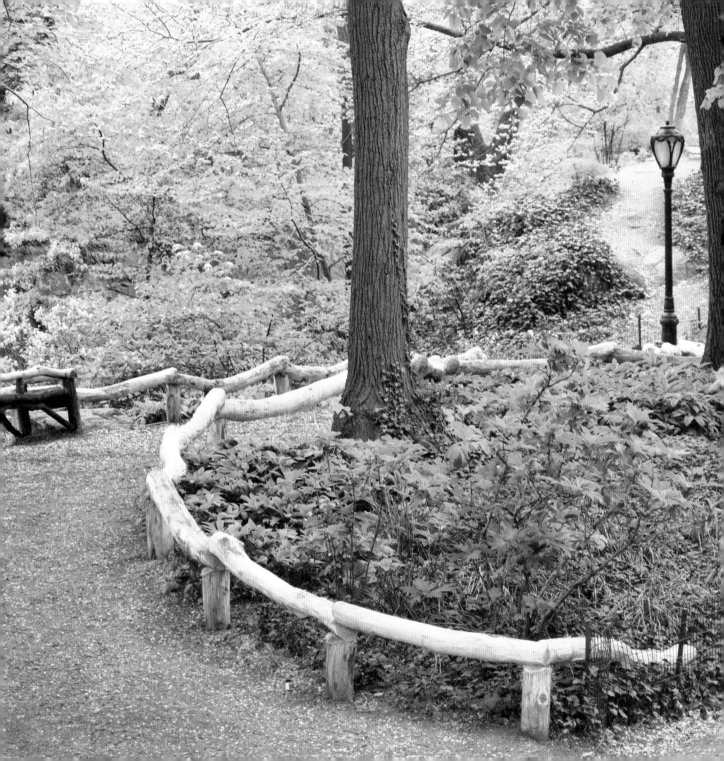

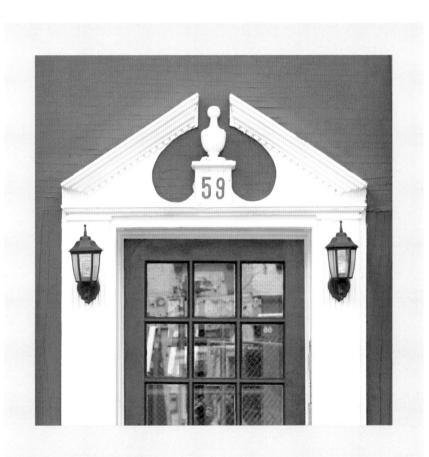

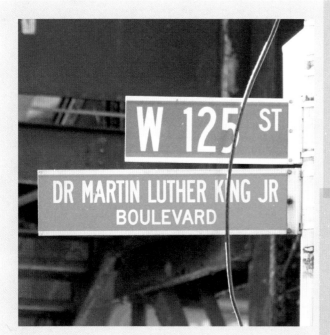

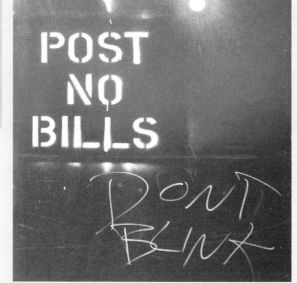

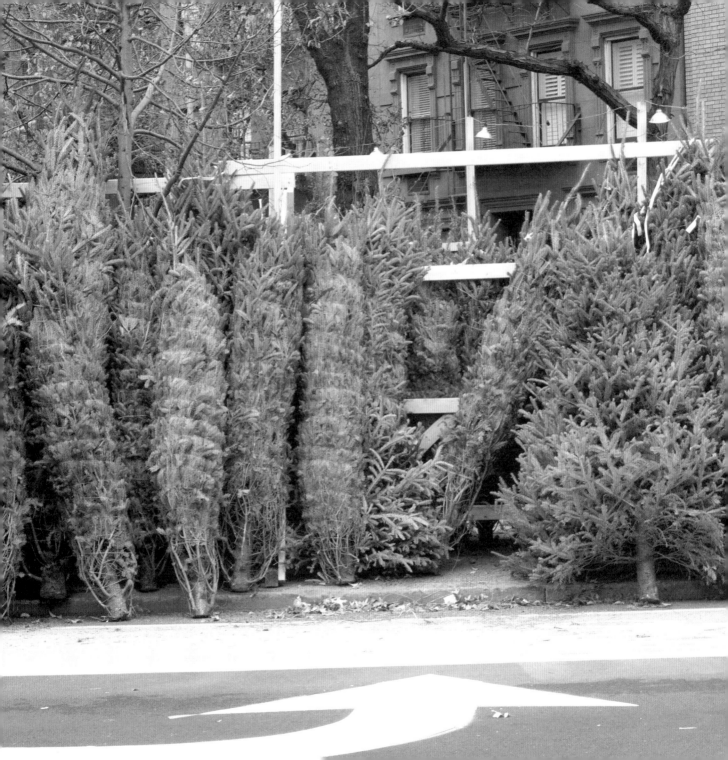

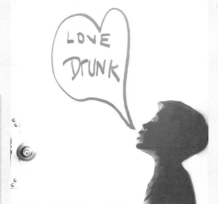
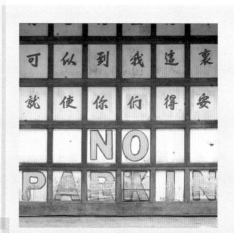
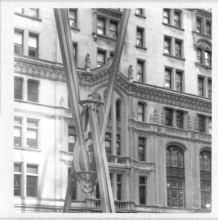
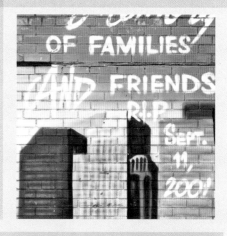
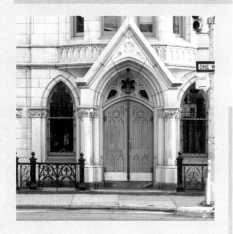
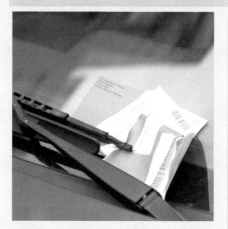
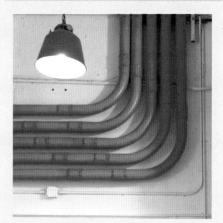

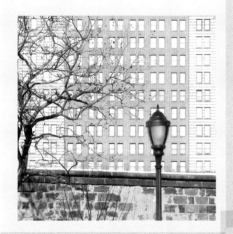

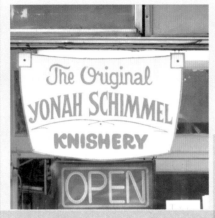

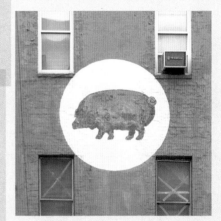

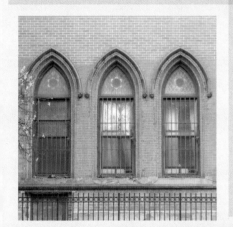

ORANGE

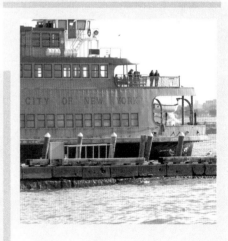

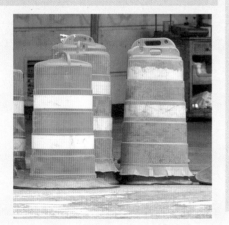

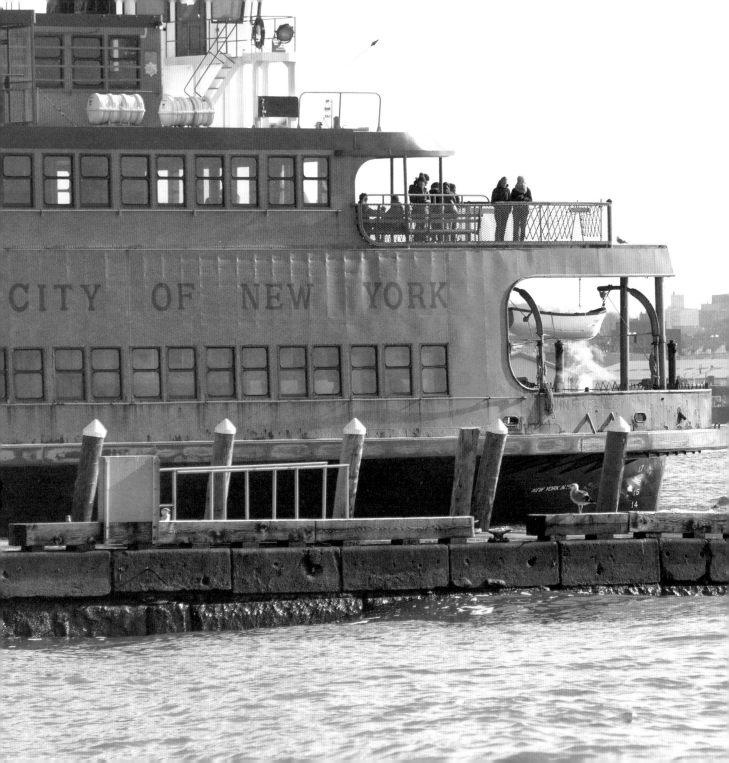

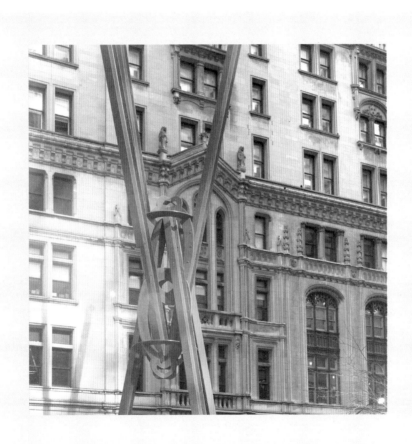

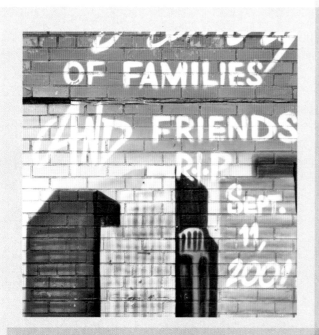

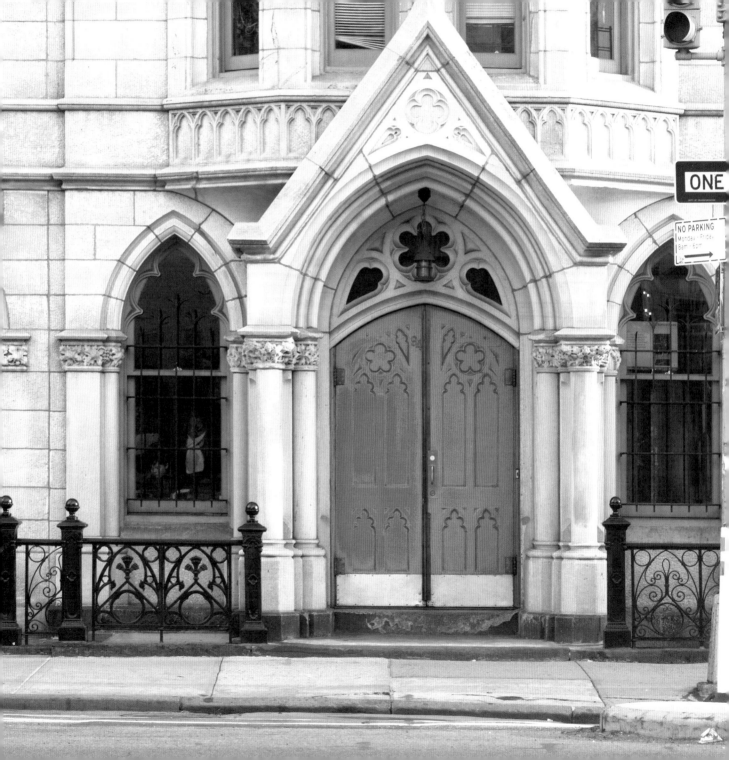

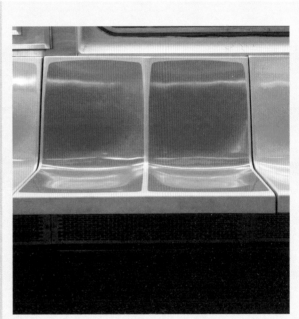

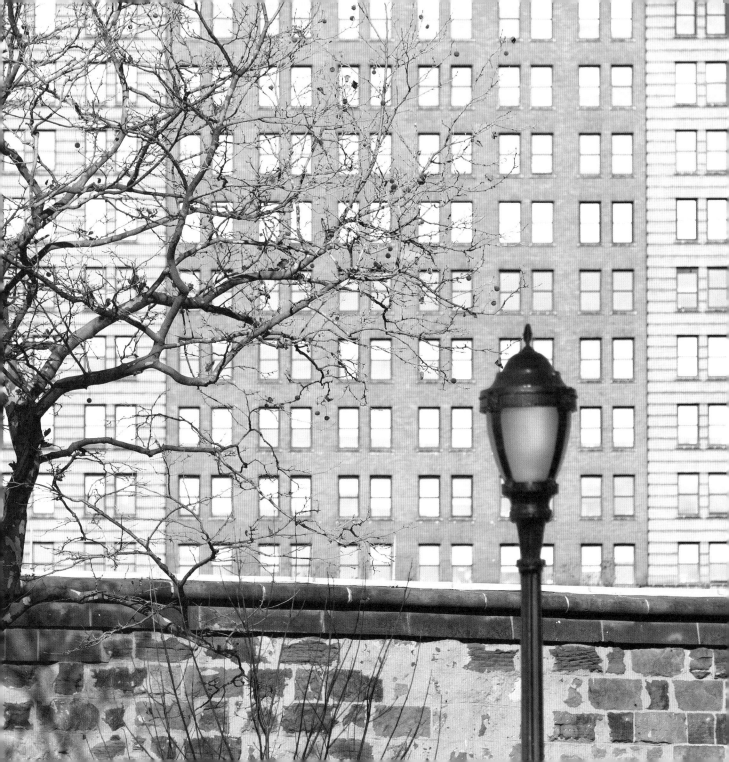

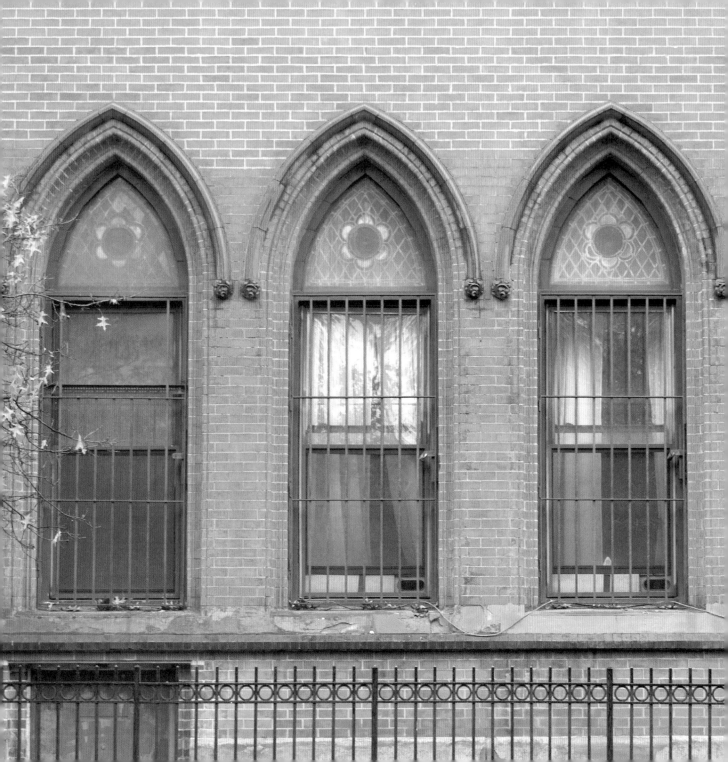

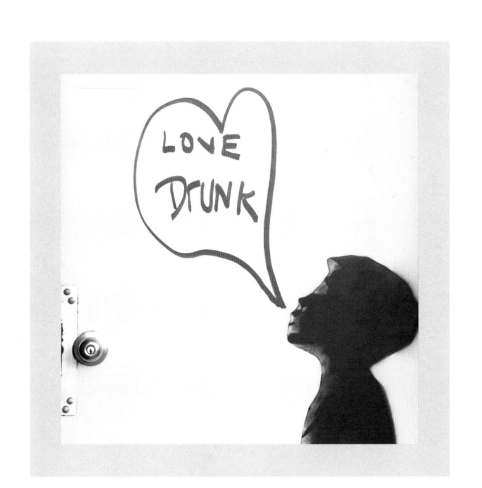

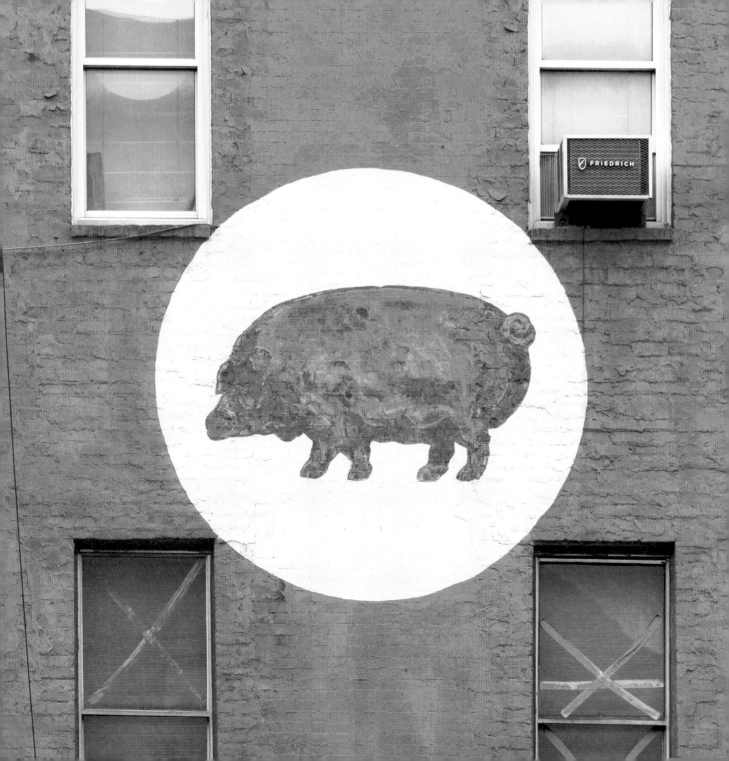

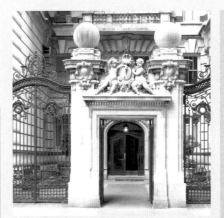

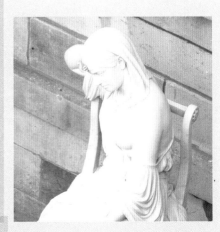

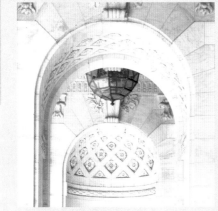

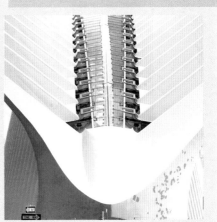

THESE PREMISES ARE
OCCUPIED BY COMPULSIVELY
OBSESSED DESSERT LOVING PEOPLE
WITH NO SELF-CONTROL
OR DISCIPLINE

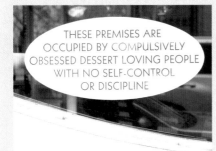

RITCHIE BILLIE MOORE · SEAMAN 2C · U.S.N.R · NORTH CAROLINA
RITTMANN ROBERT P · TORPEDOMAN'S MATE 1C · U.S.N · R.I
RIVARD LOUIS A · SEAMAN 2C · U.S.N.R · MASSACHUSETTS
ROBBINS ROSCOE L · SEAMAN 1C · U.S.N.R · MICHIGAN
ROBERGE RAYMOND C · SEAMAN 1C · U.S.N.R · CONNECTICUT
ROBERSON JOHN B · MESS ATTENDANT 2C · U.S.N · N.C
ROBERTS CHARLES E · WATER TENDER 3C · U.S.N.R · NEW YORK
ROBERTS LLOYD N · SEAMAN 2C · U.S.N.R · INDIANA
ROBERTS RAYMOND JACK · GUNNER'S MATE 1C · U.S.N · MASS
ROBERTS ROBERT H · ENSIGN · U.S.N.R · KANSAS
ROBERTSON HOWARD C JR · SEAMAN 2C · U.S.N.R · ILLINOIS
ROBERTSON JOHN A · SEAMAN 1C · U.S.N.R · MARYLAND
ROBINSON CECIL M · SEAMAN 1C · U.S.N · ALABAMA
ROBINSON FREDERICK W · CHIEF WATER TENDER · U.S.N · CALIFORNIA
ROBINSON RALPH P · SEAMAN 2C · U.S.N.R · MASSACHUSETTS
ROBISON RUSSELL H · SEAMAN 1C · U.S.N.R · OHIO
ROBUSTO LOUIS J · SEAMAN 1C · U.S.N · NEW YORK
ROCHELEAU HENRY E · WATER TENDER 2C · U.S.N.R · NEW JERSEY
ROCKFORT JOSEPH H · GUNNER'S MATE 3C · U.S.N.R · NEW JERSEY
RODMAN HAROLD R · YEOMAN 1C · U.S.N · NEW JERSEY
ROELLICH STANLEY H · SEAMAN 2C · U.S.N.R · MINNESOTA
ROGERS WARREN L JR · SEAMAN 1C · U.S.N.R · PENNSYLVANIA
ROGERS WILLIAM H · ENSIGN · U.S.N.R · WEST VIRGINIA
ROHDE HOWARD H · COXSWAIN · U.S.N · ILLINOIS
ROHNER EDWARD J · ENSIGN · U.S.N.R · IOWA
ROJEK ROMAND M · SEAMAN 1C · U.S.N.R · ILLINOIS
ROLAND MELVIN R · SEAMAN 1C · U.S.N.R · MISSOURI
ROMANELLI ERNEST JR · COXSWAIN · U.S.N · MICHIGAN
ROMANOWSKI EDWARD J · BOATSWAIN'S MATE 1C · U.S.N · DELAWARE
ROMEO PAUL · BOATSWAIN'S MATE 2C · U.S.N.R · NEW YORK
ROMINANO BENEDICT R · SEAMAN 2C · U.S.N · NEW YORK
RONALD ARCHIBALD · SEAMAN 2C · U.S.N.R · NEW YORK
ROOKER STANLEY IRVIN · FIREMAN 2C · U.S.N.R · OKLAHOMA
ROOT GEORGE E · SEAMAN 1C · U.S.N.R · ILLINOIS
ROSENBLATT MURRAY · SEAMAN 1C · U.S.N.R · NEW YORK
ROSS CHARLES F · FIREMAN 2C · U.S.N.R · MARYLAND
ROTELLA GENNARO · SEAMAN 1C · U.S.N · NEW JERSEY

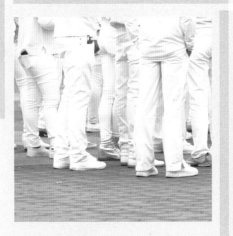

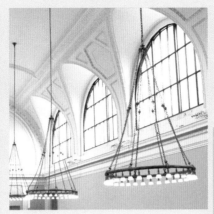

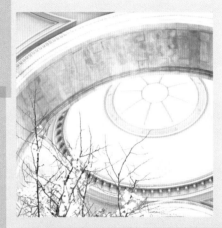

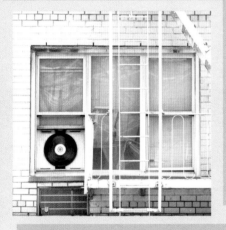

WHITE

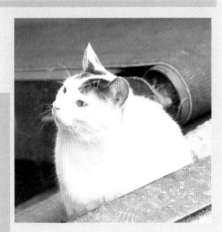

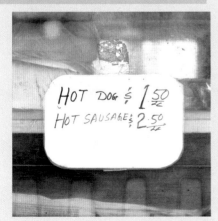

RITTMANN ROBERT P · TORPEDOMAN'S MATE IC · U S N · R
RIVARD LOUIS A · · SEAMAN 2C · · U S N R · · MASSACHUSETT
ROBBINS ROSCOE L · · SEAMAN IC · · U S N R · · MICHIGAN
ROBERGE RAYMOND C · SEAMAN IC · U S N R · CONNECTICU
ROBERSON JOHN B · · MESS ATTENDANT 2C · · U S N · · N C
ROBERTS CHARLES E · WATER TENDER 3C · U S N R · NEW YORI
ROBERTS LLOYD N · · SEAMAN 2C · · U S N R · · INDIAN
ROBERTS RAYMOND JACK · GUNNER'S MATE IC · U S N · MAS
ROBERTS ROBERT H · · ENSIGN · · U S N R · · KANSA
ROBERTSON HOWARD C JR · SEAMAN 2C · U S N R · ILLINOI
ROBERTSON JOHN A · · SEAMAN 2C · · U S N · · MARYLAN
ROBINSON CECIL M · · SEAMAN IC · · U S N R · ALABAM
ROBINSON FREDERICK W · CHIEF WATER TENDER · U S N · CALIFORNI
ROBINSON RALPH P · SEAMAN 2C · U S N R · MASSACHUSETT
ROBISON RUSSELL H · · SEAMAN IC · · U S N R · · OHIC
ROBUSTO LOUIS J · · SEAMAN IC · · U S N · · NEW YOR
ROCHEDIEU HENRY E · WATER TENDER 2C · U S N R · NEW JERSE
ROCKFORT JOSEPH H · GUNNER'S MATE 3C · U S N R · NEW JERSE
RODMAN HAROLD R · · YEOMAN IC · · U S N R · · NEW JERSE
ROELLICH STANLEY H · SEAMAN 2C · · U S N R · · MINNESOT
ROGERS WARREN L JR · SEAMAN IC · U S N R · PENNSYLVANI
ROGERS WILLIAM H · · ENSIGN · · U S N R · WEST VIRGINI
ROHDE HOWARD H · · COXSWAIN · · U S N · · ILLINOI
ROHNER EDWARD J · · ENSIGN · · U S N R · · IOW
ROJEK ROMAND M · · SEAMAN IC · · U S N R · · ILLINOI
ROLAND MELVIN R · · SEAMAN IC · · U S N R · · MISSOUR
ROMANELLI ERNEST JR · · COXSWAIN · · U S N · · MICHIGA
ROMANOWSKI EDWARD J · BOATSWAIN'S MATE IC · U S N · DELAWAR
ROMEO PAUL · · BOATSWAIN'S MATE 2C · · U S N · · NEW YOR
ROMINADO BENEDICT B · · SEAMAN 2C · · U S N · · NEW YOR
RONALD ARCHIBALD · · SEAMAN 2C · · U S N R · · NEW YOR
ROOKER STANLEY IRVIN · · FIREMAN 3C · · U S N · · OKLAHOM
ROOT GEORGE E · · SEAMAN IC · · U S N R · · ILLINOI
ROSENBLATT MURRAY · · SEAMAN IC · · U S N R · · NEW YOR
ROSS CHARLES E · · FIREMAN 2C · · U S N R · · MARYLAN
ROTELLA GENNARO · · SEAMAN IC · · U S N · · NEW JERSE

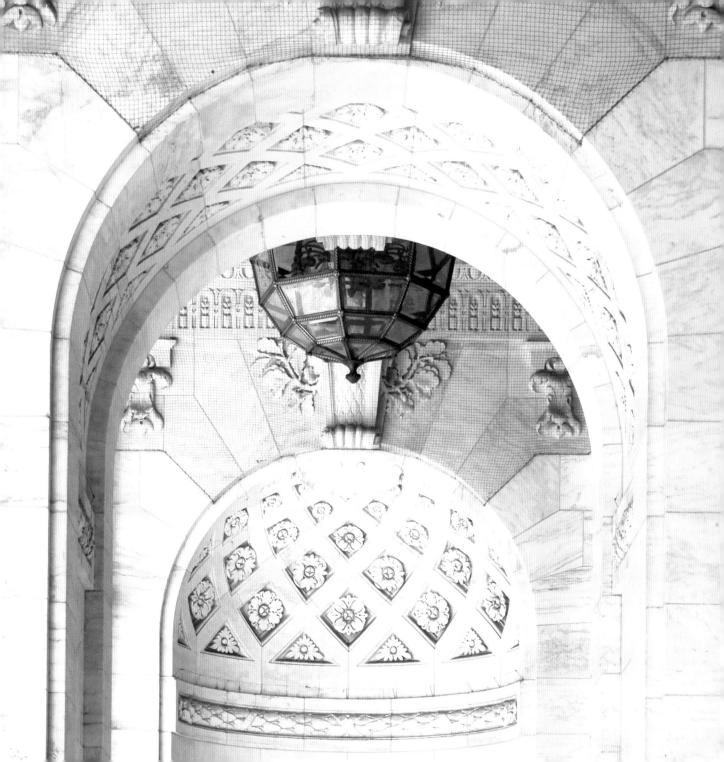

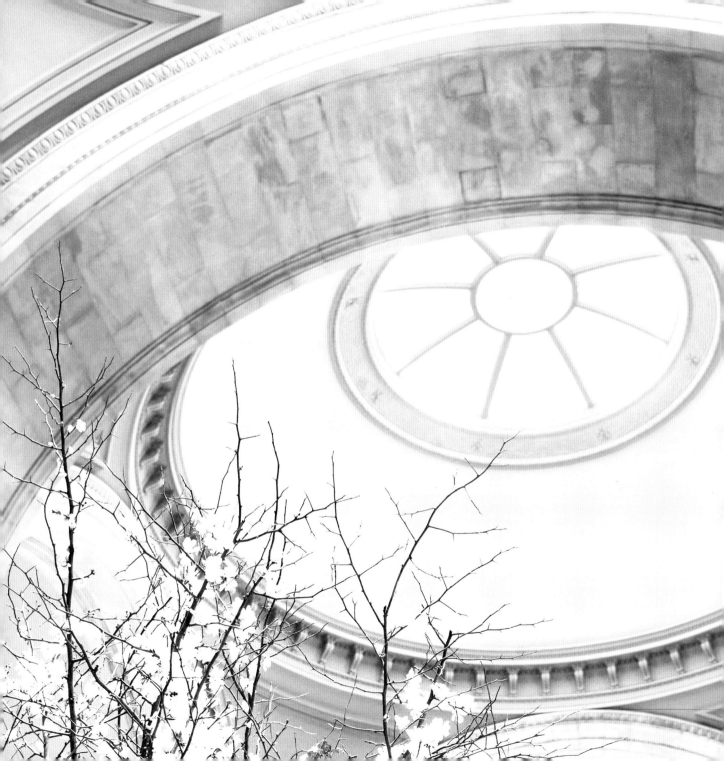

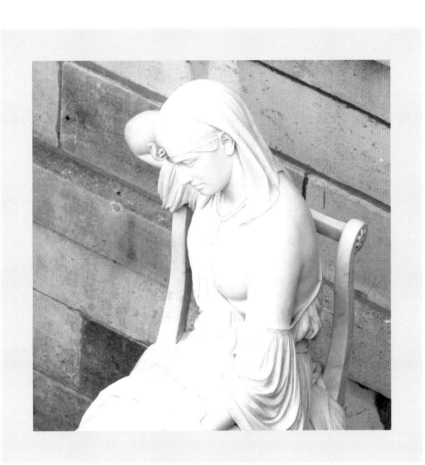

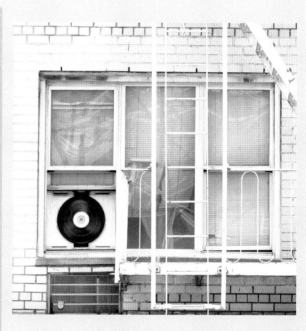

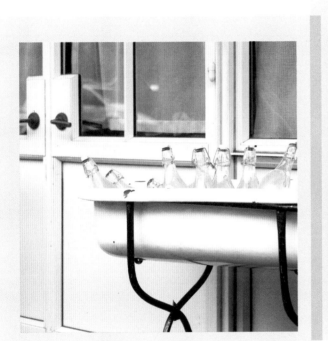

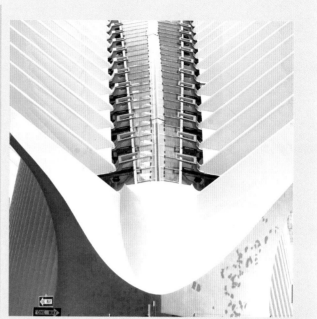

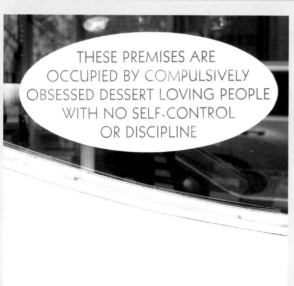

THESE PREMISES ARE
OCCUPIED BY COMPULSIVELY
OBSESSED DESSERT LOVING PEOPLE
WITH NO SELF-CONTROL
OR DISCIPLINE

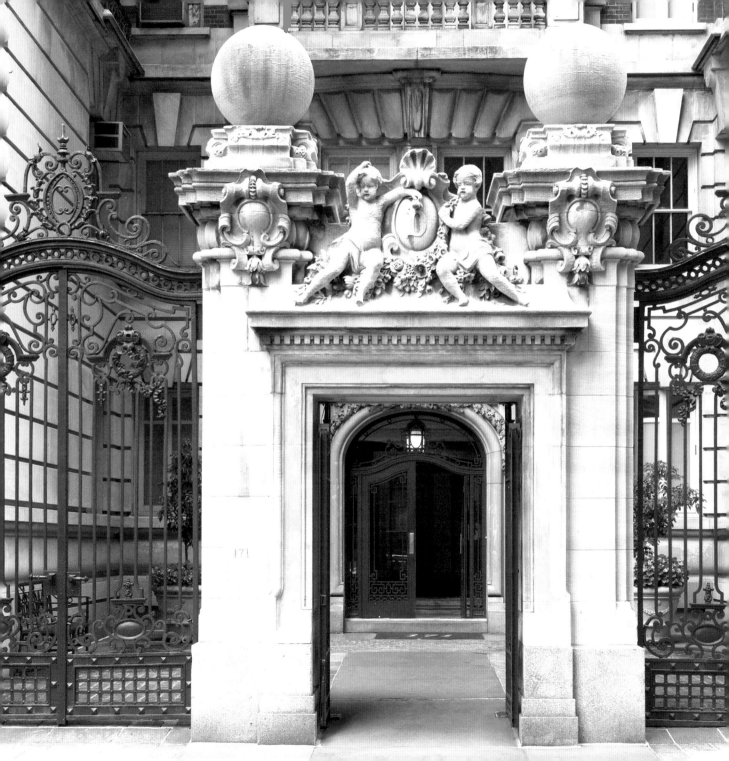

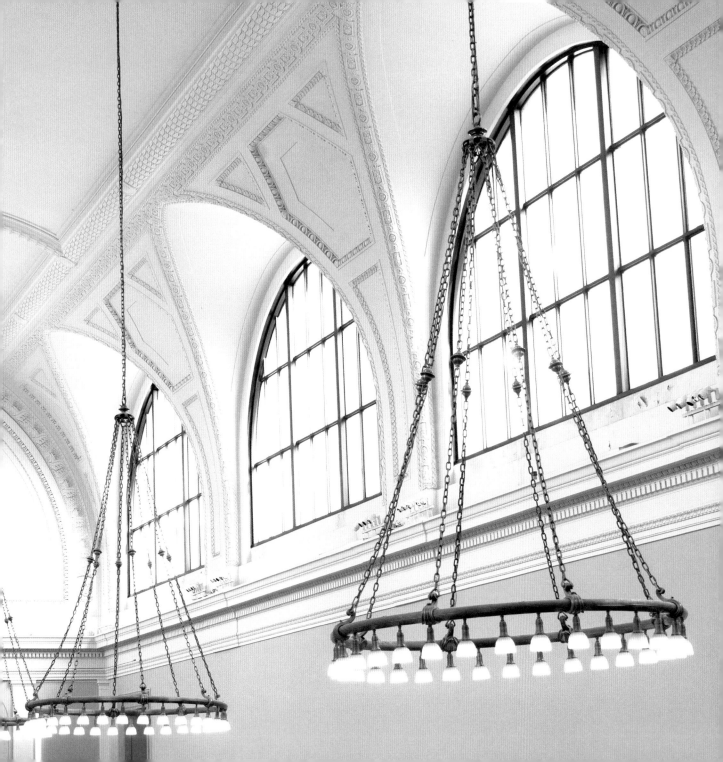

ACKNOWLEDGMENTS

I would like to thank the people of New York for infusing the city with its infectious energy.

I would like to express my gratitude to my parents who instilled me with a sense of fearlessness and optimism that contributed to me moving to New York and chasing my dreams.

I would like to thank everyone at Chronicle Books, including my initial editor, Laura Lee Mattingly, for making my first book possible; my current editor, Caitlin Kirkpatrick, for helping me refine my vision for *New York in Color*; and Kristen Hewitt for her exemplary art directing skills.

And finally, I would like to thank my husband, Evan, and my two sons, Alexander and Liam. Our journey began in New York City, and it is and always will be special because of that.